COOL
LONDON

teNeues

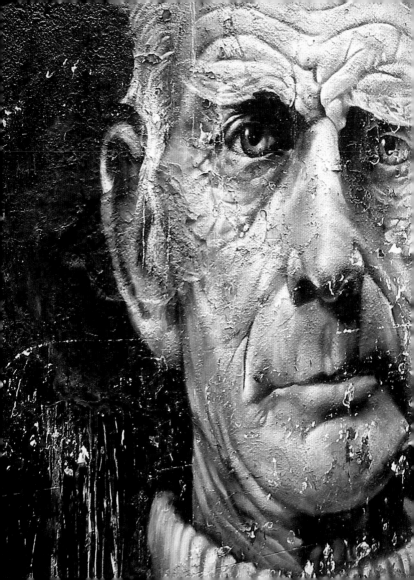

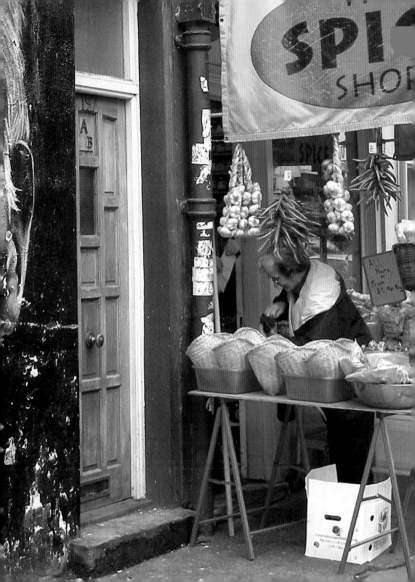

PRICE CATEGORY

$ = BUDGET $$ = AFFORDABLE $$$ = MODERATE $$$$ = LUXURY

COOL
CONTENT

INTRO

DOUBLE-DECKER BUSES, RED PHONE
BOXES, POLICEMEN IN FUNNY HATS—
YOU MIGHT THINK YOU KNOW
LONDON, BUT WE HATE TO BREAK IT
TO YOU, YOU DON'T. THERE'S MUCH
MORE TO THIS CITY THAN YOU'LL EVER
SEE ON THE FRONT OF A POSTCARD.
IN FACT, IT'S A PLACE SO LAYERED, YOU
COULD LIVE HERE ALL YOUR LIFES—AND
PLENTY DO, OVER SEVEN MILLION
PEOPLE TO BE EXACTS—AND NEVER
QUITE SCRATCH THE SURFACE. LONDON
IS A CITY OF STARTLING CONTRASTS,
WHERE TRADITION, POMP AND
CEREMONY MEET HEAD-ON WITH A NEW
MODERNITY, THE VERY THING DRIVING
THIS HUMMING METROPOLIS FORWARD,
MAKING LONDON THE PLACE TO BE IN
THE WORLD OF BUSINESS, FASHION,
CULTURE AND THE ARTS. THERE'S AN
ELECTRIC BUZZ ABOUT THE PLACE;
A TANGIBLE DESIRE TO BE IN THE HERE
AND NOW THAT YOU CAN'T HELP BUT
GET SWEPT UP IN. THAT'S WHY WE'VE
PUT TOGETHER THIS GUIDE, SO THAT
YOU TOO CAN EXPERIENCE WHAT
OUR CITY INSIDERS GET TO LIVE ON A
DAILY BASIS. THERE'S SO MUCH
TO BE DISCOVEREDS—WHAT ARE
YOU WAITING FOR?

DOPPELDECKERBUSSE, ROTE TELEFON-
ZELLEN, POLIZISTEN MIT LUSTIGER KOPF-
BEDECKUNG … SIE GLAUBEN VIELLEICHT,
SIE KENNEN LONDON, ABER DA MÜSSEN
WIR SIE LEIDER ENTTÄUSCHEN, DENN DEM
IST GEWISS NICHT SO. DIESE STADT HAT
WEITAUS MEHR ZU BIETEN ALS NUR POST-
KARTENMOTIVE. LONDON IST SO VIEL-
SCHICHTIG, DASS SIE IHR GANZES LEBEN
HIER VERBRINGEN KÖNNTEN, SO WIE DIE
MEHR ALS SIEBEN MILLIONEN EINWOHNER,
OHNE JE EINEN TIEFEREN EINBLICK ZU GE-
WINNEN. LONDON IST EINE STADT VOLLER
ÜBERRASCHENDER KONTRASTE, WO TRA-
DITION, POMP UND ZEREMONIELL DIREKT
AUF EINE MODERNITÄT TREFFEN, DIE DIESE
GESCHÄFTIGE METROPOLE VORANTREIBT
UND SIE ZU DEM BEDEUTENDSTEN ORT IN
DER WELT DER FINANZEN, MODE, KULTUR
UND KÜNSTE MACHT. EIN ELEKTRISCHES
SUMMEN UMGIBT LONDON, EIN DEUTLICH
SPÜRBARES VERLANGEN DANACH, IM HIER
UND JETZT ZU SEIN, IN DAS SIE UNVER-
MEIDLICH HINEINGEZOGEN WERDEN.
AUS DIESEM GRUND HABEN WIR DIESEN
GUIDE ZUSAMMENGESTELLT, SODASS AUCH
SIE ERLEBEN KÖNNEN, WAS DIE EINHEIMI-
SCHEN DIESER STADT TAGTÄGLICH GEBO-
TEN BEKOMMEN. ES GIBT VIEL ZU ENTDE-
CKEN, WORAUF WARTEN SIE NOCH?

INTRO

LES BUS À IMPÉRIALE, LES CABINES TÉLÉPHONIQUES ROUGES, LES BOBBIES… VOUS CROYIEZ CONNAÎTRE LONDRES, MAIS NOUS SOMMES DÉSOLÉS D'AVOIR À VOUS EN INFORMER : C'EST FAUT. CETTE VILLE A BEAUCOUP PLUS À OFFRIR QUE CE QU'ON VOIT SUR LES CARTES POSTALES. EN FAIT, C'EST UNE VILLE D'UNE RICHESSE TELLE QUE VOUS POURRIEZ Y VIVRE TOUTE VOTRE VIE (COMME BEAUCOUP D'AUTRES, PLUS DE SEPT MILLIONS DE PERSONNES POUR ÊTRE EXACT) ET NE JAMAIS VRAIMENT QU'EN EFFLEURER LA SURFACE. LONDRES EST UNE VILLE DE CONTRASTES SAISISSANTS, OÙ LA TRADITION, LA POMPE ET LES CÉRÉMONIES CÔTOIENT UNE NOUVELLE MODERNITÉ. C'EST LÀ MÊME LE MOTEUR QUI POUSSE DE L'AVANT CETTE MÉTROPOLE QUI RONRONNE, FAISANT D'ELLE LE LIEU DES AFFAIRES, DE LA MODE, DE LA CULTURE ET DES ARTS. UN BOURDONNEMENT ÉLECTRIQUE ÉMANE DU LIEU. IL VOUS INSPIRE UN DÉSIR TANGIBLE DE FAIRE PARTIE D'UN ICI ET MAINTENANT AUQUEL IL EST DIFFICILE DE RÉSISTER. C'EST POURQUOI NOUS AVONS ÉLABORÉ CE GUIDE, DE SORTE QUE VOUS POUVEZ VOUS AUSSI PROFITER DE CE QUE NOS EXPERTS CONNAISSENT AU QUOTIDIEN. IL Y A TELLEMENT À DÉCOUVRIR : QU'ATTENDEZ-VOUS?

AUTOBUSES DE DOS PISOS, CABINAS TELEFÓNICAS ROJAS, AGENTES DE POLICÍA CON CASCOS ESTRAFALARIOS… PUEDE QUE PIENSE QUE CONOCE LONDRES, PERO, MAL QUE NOS PESE DECÍRSELO, NO ES ASÍ. ESTA CIUDAD TIENE MUCHO MÁS PARA OFRECER DE LO QUE PUEDE VERSE EN LAS POSTALES. EN REALIDAD, ES UN LUGAR TAN MULTIFACÉTICO QUE PODRÍA UNO VIVIR AQUÍ TODA SU VIDA (COMO HACEN MUCHAS PERSONAS; SIETE MILLONES, PARA SER EXACTOS) SIN LLEGAR A DESCUBRIR MÁS QUE UNA ÍNFIMA PARTE. LONDRES ES UNA CIUDAD DE CONTRASTES ASOMBROSOS, EN LA QUE LA TRADICIÓN, LA POMPA Y LA CEREMONIA CONVIVEN CON UNA NUEVA MODERNIDAD QUE MANTIENE EN MARCHA ESTA BULLICIOSA METRÓPOLIS Y HACE DE ELLA ESPACIO DE REFERENCIA EN EL PLANO DE LOS NEGOCIOS, LA MODA, LA CULTURA Y LAS ARTES. LA ATMÓSFERA EN LA CIUDAD ES ELECTRIZANTE; EXISTE UNA VOLUNTAD TANGIBLE DE DESCUBRIR EL INSTANTE, EL AHORA, Y RESULTA IMPOSIBLE NO VERSE ARRASTRADO POR ESE ÍMPETU. POR ESO HEMOS CREADO ESTA GUÍA, PARA QUE TAMBIÉN USTED PUEDA EXPERIMENTAR LO QUE QUIENES CONOCEN LA CIUDAD VIVEN CADA DÍA. HAY MUCHÍSIMAS COSAS POR DESCUBRIR: ¿A QUÉ ESPERA?

HOTELS

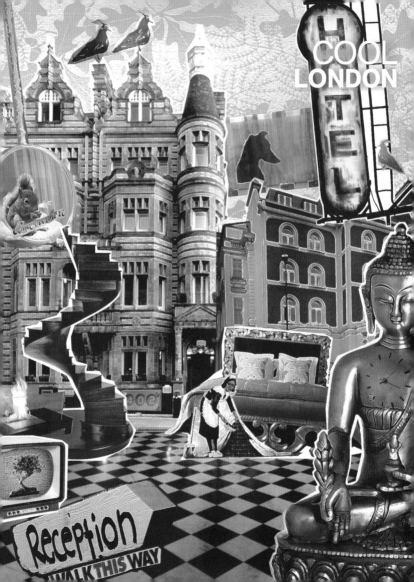

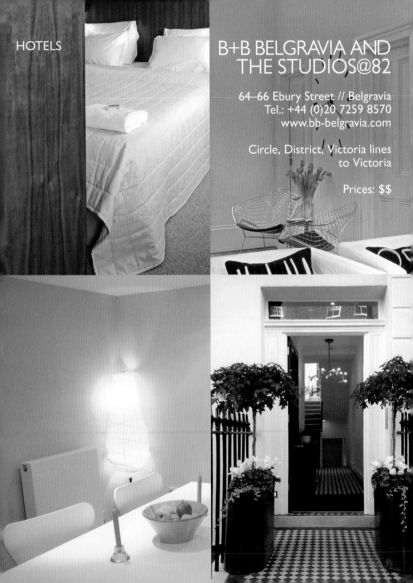

HOTELS

B+B BELGRAVIA AND THE STUDIOS@82

64–66 Ebury Street // Belgravia
Tel.: +44 (0)20 7259 8570
www.bb-belgravia.com

Circle, District, Victoria lines
to Victoria

Prices: $$

Think B+Bs are all chintzy bedspreads, tired sagging mattresses and soggy toast in the morning? Think again! The team behind B+B Belgravia are hell-bent on reinventing the bed and breakfast concept—whilst still making things affordable. Chic and stylish, all the rooms are beautifully simple, and breakfast is served in the downstairs breakfast room. If you want more privacy there's The Studios@82, also on Ebury Street, where breakfast is brought to your very own studio apartment. Now that's more like it!

Wenn Sie Bed and Breakfasts hören, denken Sie an geschmacklose Tagesdecken, durchgelegene Matratzen und labbrigen Toast zum Frühstück? Dann lassen Sie sich eines Besseren belehren! Das Team von B+B Belgravia ist fest entschlossen, das Bed-and-Breakfast-Konzept neu zu erfinden und dabei noch erschwinglich zu bleiben. Die Räume sind allesamt schick und stilvoll und überzeugen durch wunderbare Schlichtheit. Frühstück wird treppab im Frühstückssaal serviert. Mehr Privatsphäre wird Ihnen in The Studios@82, ebenfalls in der Ebury Street, geboten. Hier wird das Frühstück sogar in Ihre eigene Atelierwohnung gebracht. Genau so muss es sein!

Si vous pensez que les couvre-lits misérables, les matelas affaissés et fatigués et les toasts défraîchis du matin sont caractéristiques des B+B, détrompez-vous ! L'équipe de B+B Belgravia s'échine à réinventer le concept du Bed and Breakfast pour un prix abordable. Élégantes et chic, toutes les chambres sont tout simplement magnifiques, et le petit-déjeuner est servi dans la salle à manger du bas. Si vous voulez quelque chose de plus privé, choisissez plutôt The Studios@82, également sur Ebury Street, où l'on vous sert le petit déjeuner directement dans votre propre studio. C'est encore meilleur comme ça !

Si es de los que piensa que un B&B es siempre sinónimo de colchas de encaje, colchones desfondados y paupérrimos desayunos, tenemos una sorpresa para usted. El equipo responsable del B+B Belgravia se ha propuesto reinventar el concepto de bed and breakfast sin que por ello deje de ser asequible. Elegante, atractivo, todas sus habitaciones son de una hermosa sencillez. El desayuno se sirve en el comedor de la planta baja. Si desea más privacidad, tiene también The Studios@82, en la misma Ebury Street, donde le llevan aun el desayuno a su propio estudio. ¡Así se hacen las cosas!

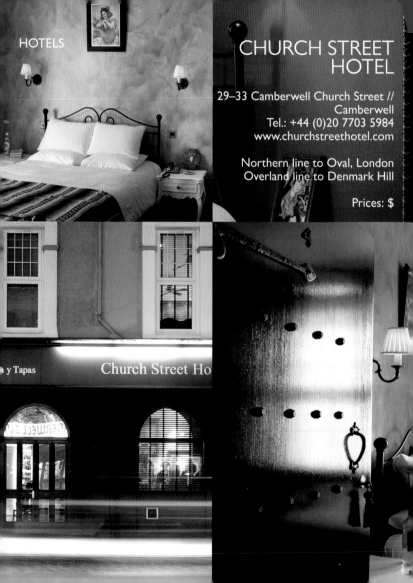

HOTELS

CHURCH STREET
HOTEL

29–33 Camberwell Church Street //
Camberwell
Tel.: +44 (0)20 7703 5984
www.churchstreethotel.com

Northern line to Oval, London
Overland line to Denmark Hill

Prices: $

Church Street Ho[tel]

y Tapas

Think Camberwell, South London, and the bold, bright hues of Mexico and Cuba don't naturally spring to mind. Sure, this is a colourful area, but a little slice of Havana right in the centre of town? You've got to be kidding! But venture south of the border and that's exactly what you'll find at this eccentric and gorgeously quirky little boutique hotel. Each room is decorated with a Mexican/Cuban aesthetic and is a delight to behold. BYO Tequila—and hangover!

Wenn Sie an Camberwell im Süden Londons denken, kommen Ihnen nicht gerade die auffallend heiteren Farbtöne Mexikos und Kubas in den Sinn. Sicherlich ist auch Camberwell eine Gegend reich an Farben, aber es als Havanna im Herzen Londons zu bezeichnen, dürfte wohl übertrieben sein, oder? Südlich der Stadtgrenze stoßen Sie jedoch genau darauf, wenn Sie sich in das exzentrische und wunderbar eigentümliche kleine Boutique-Hotel begeben. Jedes Zimmer ist im mexikanisch-kubanischen Stil gestaltet und verspricht einen unvergesslichen Aufenthalt. Genießen Sie die Tequila-Vorräte und lassen Sie die Seele baumeln!

Quand on pense à Camberwell, au sud de Londres, les couleurs vives et marquées du Mexique ou de Cuba ne viennent pas naturellement à l'esprit. Bien sûr, il s'agit d'un quartier pittoresque, mais un petit bout de la Havane en plein centre-ville ? C'est surement une blague ! Mais si vous vous aventurez dans les quartiers sud, c'est exactement ce que vous trouverez dans cet hôtel de charme excentrique et un rien décalé. Chaque chambre est décorée selon une esthétique mexicaine ou cubaine, et c'est un régal pour les yeux. Un lieu idéal pour s'attarder autour d'une bouteille de téquila !

Al pensar en Camberwell, al sur de Londres, a uno no le vienen de inmediato a la mente las tonalidades brillantes y chillonas de México y Cuba. Sí, es un área con mucho colorido, pero ¿La Habana en el centro mismo de la ciudad? ¡Venga ya! Sin embargo, eso es precisamente lo que encontramos en este excéntrico y esplendorosamente extravagante hotelito. Cada habitación está decorada con estética cubano-mexicana y es un verdadero placer para la vista. El tequila (y las resacas) lo ponen los huéspedes.

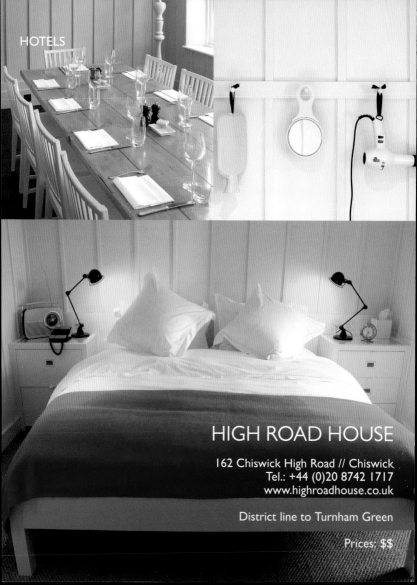

HIGH ROAD HOUSE

162 Chiswick High Road // Chiswick
Tel.: +44 (0)20 8742 1717
www.highroadhouse.co.uk

District line to Turnham Green

Prices: $$

OK, so it's 20 minutes outside central London, but we'd take the high road to this gorgeous boutique hotel in West London any day. As well as being a private member's club—members get discounts to the hotel and are allowed to invite guests—there are 14 small rooms available to stay. Light and bright, they have white-painted wood panels on the walls and lots of natural materials. There's also a great restaurant and bar. Stay snug as a bug inside your deluxe cocoon.

Zugegebenermaßen sind 20 Minuten außerhalb Londons Innenstadt kein Katzensprung. Für dieses traumhafte Boutique-Hotel im Westen Londons würden wir jedoch an jedem beliebigen Tag den etwas längeren Weg in Kauf nehmen. Es handelt sich sowohl um einen Privatklub, in dem Mitgliedern Nachlässe gewährt werden und diese Gäste mitbringen dürfen, und es stehen auch 14 kleine Zimmer für einen Aufenthalt zur Verfügung. Die Wände dieser hellen und freundlichen Zimmer sind mit weiß gestrichenem Holz verkleidet, und eine Vielzahl an Naturmaterialien schmückt die Räume. Außerdem gibt es auch ein fantastisches Restaurant und eine tolle Bar. Dieser Luxus-Kokon lädt dazu ein, sich rundum wohlzufühlen.

D'accord, c'est à 20 minutes à l'extérieur du centre de Londres, mais on prendrait le large n'importe quand pour séjourner dans ce magnifique hôtel de charme de l'ouest londonien. En plus d'être un club privé – où les membres bénéficient de réductions à l'hôtel mais où les clients de passage peuvent réserver – il comporte 14 petites chambres à la disposition des clients. Lumineux et clair, elles sont décorées de panneaux de bois peints en blanc sur les murs et de nombre de matériaux naturels. Il y a aussi un grand restaurant et un bar. Hibernez comme une marmotte dans votre terrier de luxe.

Es cierto que se encuentra a 20 minutos del centro de Londres, pero alojarse en este extraordinario y coqueto hotel al oeste de la ciudad bien vale el trayecto extra. Además de ser un club privado (sus miembros disponen de descuento en el hotel y están autorizados a llevar invitados), cuenta con 14 pequeñas habitaciones para el público muy luminosas, con enmaderados blancos en las paredes y gran número de materiales naturales. El bar y el restaurante son también de primer orden. Un lujosísimo refugio en el que sentirse como en casa.

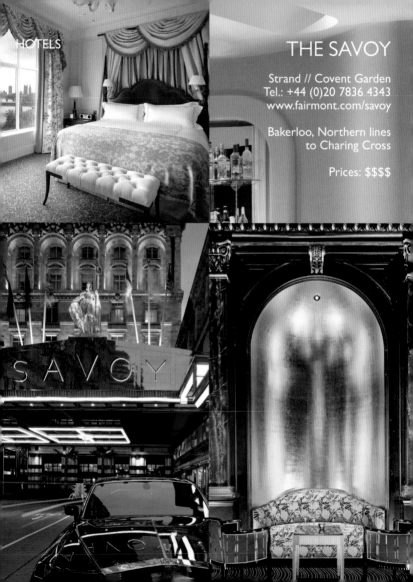

HOTELS

THE SAVOY

Strand // Covent Garden
Tel.: +44 (0)20 7836 4343
www.fairmont.com/savoy

Bakerloo, Northern lines
to Charing Cross

Prices: $$$$

SAVOY

The Savoy is to London hotels what Big Ben is to its landmarks—quite simply, irreplaceable. Iconic since its grand opening in 1889, this exclusive hotel is back to its historic best, thanks to a £100 million refit. Nine "personality suites" have been styled after some of the hotel's most famous guests, including Marlene Dietrich, Frank Sinatra, Claude Monet—and even Charlie Chaplin. For those with loftier ambitions, there's also the Royal Suite, which occupies the entire front of the 5th floor. Fit for a King—literally!

Das Savoy ist unter Londoner Hotels das, was der Big Ben unter den Wahrzeichen ist – ganz einfach unersetzlich. Seit der großen Eröffnung im Jahr 1889 hat es nichts von seiner Symbolträchtigkeit eingebüßt und dank einer Sanierung im Wert von £100 Millionen erstrahlt dieses vornehme Hotel wieder in seinem historischen Glanz. Neun Suiten wurden in Anlehnung an einige der berühmtesten Gäste des Hotels gestaltet, darunter auch Marlene Dietrich, Frank Sinatra, Claude Monet und sogar Charlie Chaplin. Auf diejenigen, die es vornehmer mögen, wartet die Royal Suite, die die gesamte Vorderseite des 5. Stockwerks einnimmt. Ein Hotel, das buchstäblich eines Königs würdig ist!

RANKIN'S SPECIAL TIP

Even after its restoration, The Savoy remains classic and iconic.

Le Savoy est aux hôtels de Londres ce que Big Ben est à ses attractions : tout simplement, irremplaçable. Emblématique depuis son ouverture en 1889, cet hôtel select a retrouvé son meilleur état, grâce à une restauration de 100 millions de Livres Sterling. Neuf « personality » suites' se sont inspirées de certains des clients les plus célèbres de l'hôtel, dont Marlene Dietrich, Frank Sinatra, Claude Monet, et même Charlie Chaplin. Pour ceux dont l'ambition atteint les sommets, il y a aussi la Suite Royale, qui occupe tout le front du 5e étage. Digne d'un roi. Littéralement !

El Savoy es a los hoteles de Londres lo que el Big Ben es a los monumentos: incomparable, simplemente. Auténtico icono desde que abriera sus puertas en 1889, el exclusivo establecimiento reverdece sus glorias gracias a los 100 millones de libras invertidas en su renovación. Nueve suites llevan el nombre de algunos de los más famosos huéspedes, entre ellos Marlene Dietrich, Frank Sinatra, Claude Monet y el mismísimo Charlie Chaplin. Quienes tengan más altas aspiraciones tienen a su disposición la suite real, que ocupa todo el frente del quinto piso y es, literalmente, digna de un rey.

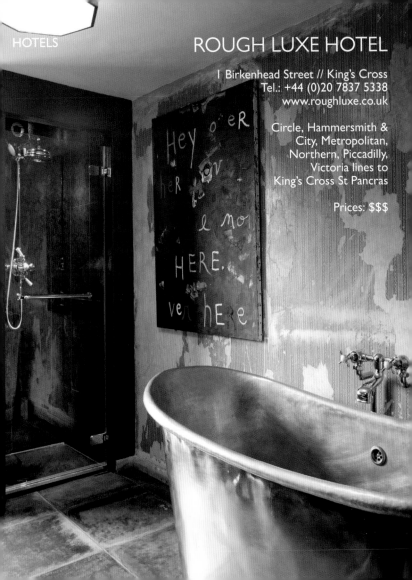

OK, so you might be sharing your bathroom, and your bedroom might be the size of the aforementioned, but that's not to say this place isn't decidedly spoil-yourself-rotten. In fact, it's absolutely divinely decadent in its simplicity! Realised by acclaimed designer Rabih Hage, each of the nine rooms in this boutique hotel has a mixture of old and new furnishings and art, and is of equal wonder to behold. The service is amazing.

Nun ja, vielleicht müssen Sie Ihr Badezimmer mit Anderen teilen und Ihr Schlafzimmer mag die Größe eines Abstellraums haben. Das ist jedoch noch lange kein Grund zu sagen, dieser Ort wäre nicht zweifelsfrei geeignet, um sich verwöhnen zu lassen. Denn tatsächlich ist es so, dass dieses Boutique-Hotel eben gerade durch seine Einfachheit göttlich dekadent ist! Durch die Hand des berühmten Designers Rabih Hage entstanden die neun Räume des Hotels in einem Mix aus antiker und moderner Möblierung und Kunst. Jedes Zimmer verschafft seinen Gästen unvergessliche Momente und der Service wird Ihnen die Sprache verschlagen.

Il est vrai que vous devrez partager votre salle de bain et votre chambre sera peut-être aux dimensions de cette dernière, mais ça ne veut pas dire que vous n'y serez pas gâté-pourri. En fait, le lieu est divinement décadent dans sa simplicité ! Réalisées par le célèbre designer Rabih Hage, les neuf chambres de cet hôtel de charme comportent toutes un mélange de mobilier ancien et nouveau et d'œuvres d'art et elles sont toutes un enchantement pour l'œil. Le service est incroyable.

De acuerdo: los baños son compartidos, y puede que los dormitorios tengan el tamaño de un cuartito de baño, pero eso no significa que en este establecimiento no le mimen a uno hasta el exceso. En realidad, su sencillez resulta de una decadencia divina. Concebido por el reputado diseñador Rabih Hage, cada una de las nueve habitaciones de este coqueto hotel combina elementos antiguos y modernos y constituye un prodigio visual. El servicio es también excepcional.

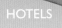

THE BERKELEY

Wilton Place // Knightsbridge
Tel.: +44 (0)20 7235 6000
www.the-berkeley.co.uk

Piccadilly line to Hyde Park Corner, Jubilee,
Piccadilly, Victoria lines to Green Park

Prices: $$$$

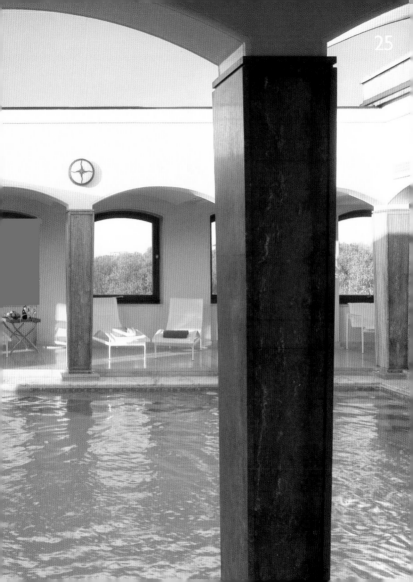

Whether you're in town on business or just looking for somewhere to base yourself between mad bursts of frenetic shopping, we can't think of a nicer place to stay than The Berkeley. The hotel, which has been operating for over 100 years, oozes quiet sophistication without losing any of its cosy charm. The suites are the most impressive. If you're after a sense of space then book the Grosvenor Conservatory Suite—it comes with its own private roof terrace with sweeping views of St Paul's.

Ob Sie sich nun auf Geschäftsreise befinden oder nur eine Zwischenstation für wilde Shoppinglaunen benötigen, es gibt keinen schöneren Ort für Ihren Aufenthalt als das Berkeley. Das Hotel ist bereits seit mehr als 100 Jahren in Betrieb und strahlt eine ruhige Überlegenheit aus, ohne dabei von seinem anheimelnden Charme einzubüßen. Besonders beeindruckend sind die Suiten. Steht Ihnen der Sinn nach viel Platz, dann reservieren Sie die Grosvenor Conservatory Suite, die über eine private Dachterrasse mit einem herrlichen Blick auf die Kathedrale St Paul's verfügt.

Que vous soyez en ville pour affaires ou simplement à la recherche d'un lieu de repos entre des sorties de folie ou de shopping frénétique, nous ne pouvons vous recommander plus agréable que le Berkeley. L'hôtel est ouvert depuis plus de 100 ans. Il fleure bon la sophistication tranquille, sans rien perdre de son charme douillet. Les suites y sont très impressionnantes. Si vous avez besoin d'espace, réservez donc la suite du Grosvenor Conservatory : elle possède sa propre terrasse privée avec une vue imprenable sur la Cathédrale St Paul.

Tanto si está en la ciudad por negocios como si necesita una base en la que descansar entre compra y compra, no sabríamos recomendar un alojamiento más agradable que el Berkeley. El hotel lleva más de 100 años en funcionamiento y rebosa serena sofisticación, sin perder por ello ni un ápice de su confortable encanto. Las suites son particularmente impresionantes. Si desea sentir tangiblemente los espacios, reserve la suite Grosvenor Conservatory, que cuenta con una azotea privada y extensas vistas sobre St Paul's.

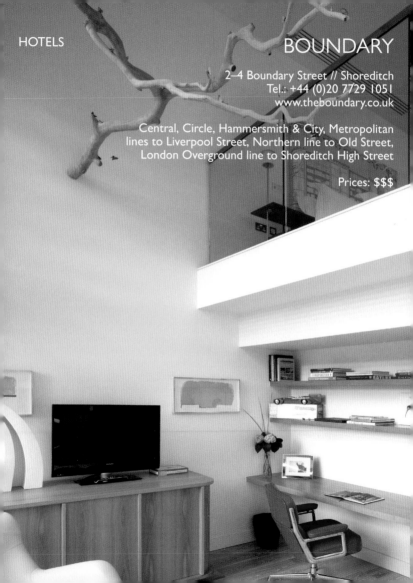

BOUNDARY

2–4 Boundary Street // Shoreditch
Tel.: +44 (0)20 7729 1051
www.theboundary.co.uk

Central, Circle, Hammersmith & City, Metropolitan
lines to Liverpool Street, Northern line to Old Street,
London Overground line to Shoreditch High Street

Prices: $$$

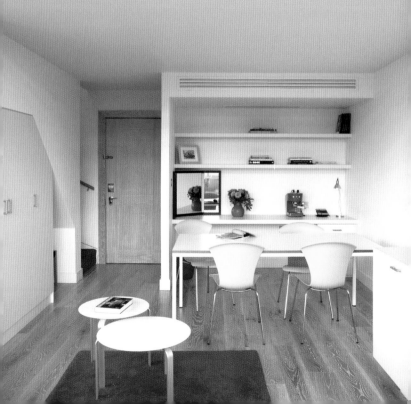

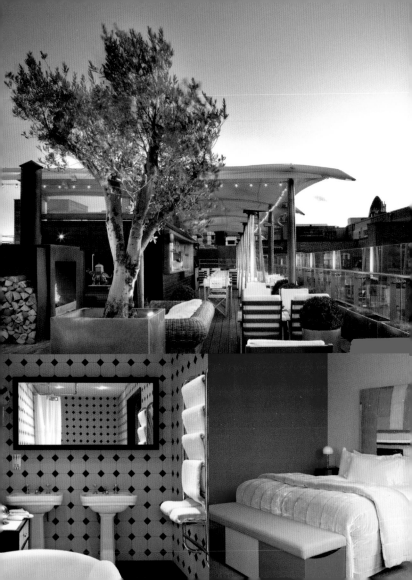

In the heart of London's Shoreditch lies Boundary, a hotel conceived by Terence and Vicki Conran in partnership with Peter Prescott. Each of the hotel's 17 rooms is inspired by legendary designers or design movements—and each is equally stylish. Guests can choose The Charles and Ray Eames Room, The Bauhaus Room or appreciate a more austere aesthetic in the charmingly designed Shaker Room, with many more on offer. There's a panoramic roof terrace and Albion cafe below, which does a sublime breakfast.

Im Herzen von Londons Stadtviertel Shoreditch befindet sich das Hotel Boundary, das von Terence und Vicki Conran in Zusammenarbeit mit Peter Prescott konzipiert wurde. Alle 17 Zimmer des Hotels sind von legendären Designern oder Design-Bewegungen inspiriert und jedes Einzelne ist gleichermaßen stilvoll. Die Gäste können unter anderen zwischen dem Charles-and-Ray-Eames- und dem Bauhaus-Zimmer wählen oder sich an der schmuckloseren Ästhetik des bezaubernden Shaker-Zimmers erfreuen. Auf der Panorama-Dachterrasse genießt man den Ausblick und in dem darunter liegenden Albion-Café ein grandioses Frühstück.

Au cœur du quartier londonien de Shoreditch se trouve le Boundary, un hôtel conçu par Terence et Vicki Conran en partenariat avec Peter Prescott. Chacune des 17 chambres de l'hôtel s'inspire des concepteurs célèbres ou des mouvements du design et chacune d'entre elles est tout aussi élégante. Les clients peuvent choisir la Charles and Ray Eames Room, la Bauhaus Room ou apprécier l'esthétique plus austère du design charmant de la Shaker Room, ou de beaucoup d'autres encore. L'hôtel possède un toit en terrasse panoramique et le café Albion en rez-de-chaussée sert un petit-déjeuner sublime.

En el corazón mismo de Shoreditch se encuentra Boundary, el hotel creado por Terence y Vicki Conran en cooperación con Peter Prescott. Cada una de las 17 habitaciones del hotel se inspira en legendarios diseñadores o tendencias de diseño, y todas rezuman elegancia. Los huéspedes pueden optar por la habitación Charles and Ray Eames, la habitación Bauhaus o decidirse por la placentera austeridad de la habitación Shaker, entre otras muchas. El establecimiento cuenta con una terraza panorámica; el café Albion, en la planta baja, ofrece desayunos sublimes.

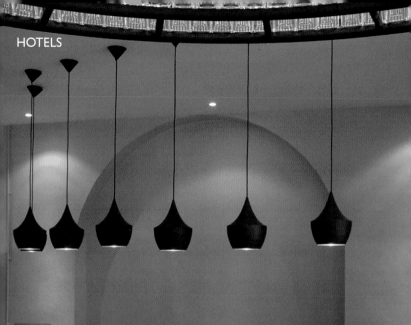

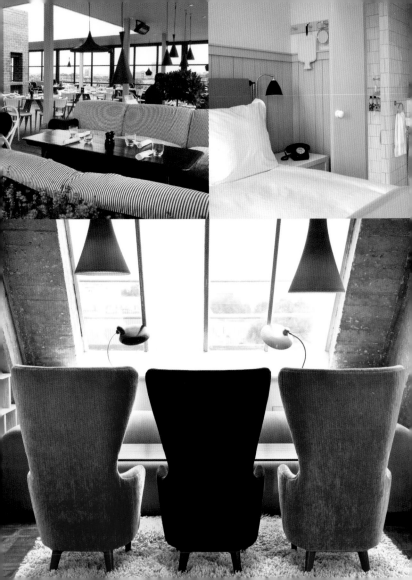

Take a trip up to the rooftop at Shoreditch House and you could be sitting poolside at some hip West Hollywood hangout—not slap bang in the middle of East London. Which, in our opinion, is far cooler, thanks very much. This amazing heated pool—as well as the accompanying day spa—is available for guests at Shoreditch Rooms, the hotel on offer at this exclusive members-only club. Rooms are surprisingly inexpensive and have great views. Not a Hollywood sign in sight.

Wenn Sie sich auf das Dach des Shoreditch House begeben, ist es, als wären Sie direkt am Pool eines angesagten West-Hollywood-Treffs gelandet und nicht etwa direkt im Herzen von East London, was aus unserer Sicht der Dinge weitaus cooler ist. Der atemberaubende beheizte Pool sowie das dazugehörige Day Spa stehen den Gästen der Shoreditch Rooms zur Verfügung. Dabei handelt es sich um das Hotel, das sich innerhalb dieses exklusiven Privatklubs befindet. Die Zimmer sind überraschenderweise erschwinglich und bieten fantastische Aussichten. Weit und breit kein Hollywood-Schriftzug in Sicht.

Faites un tour sur le toit de Shoreditch House et vous pourriez être assis près de la piscine de quelque repaire hype de West Hollywood, pas en plein milieu de l'est londonien, ce qui est, à notre avis, bien plus cool, merci beaucoup ! Cette très belle piscine chauffée, et le spa de jour qui l'accompagne, sont réservés aux clients des chambres du Shoreditch, un service d'hôtellerie exclusivement réservés aux membres du club. Les chambres sont étonnamment abordables et profitent de vues magnifiques. Aucun panneau hollywoodien en vue.

Al subir a la azotea de Shoreditch House, uno no sabe si se encuentra en la piscina de una suntuosa mansión en West Hollywood o en el centro mismo del este de Londres, el cual, en nuestra opinión, es mucho más atractivo. La asombrosa piscina climatizada (así como el resto del spa) está a disposición de los clientes de Shoreditch Rooms, el hotel exclusivo para miembros de este selecto club. Las habitaciones son sorprendentemente asequibles y ofrecen magníficas vistas. ¿Y el cartel de Hollywood? No se ve por ninguna parte.

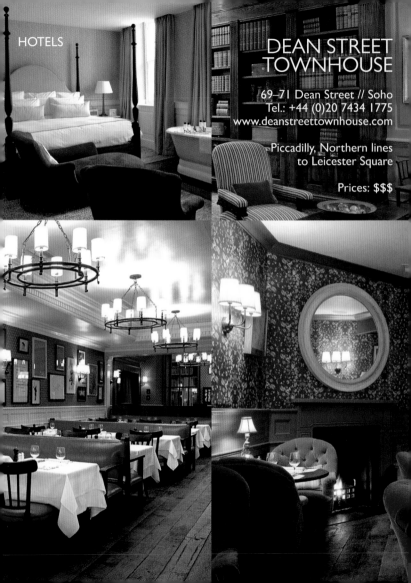

HOTELS

DEAN STREET TOWNHOUSE

69–71 Dean Street // Soho
Tel.: +44 (0)20 7434 1775
www.deanstreettownhouse.com

Piccadilly, Northern lines
to Leicester Square

Prices: $$$

Planning on spending a fair amount of time in Soho? This charming hotel, owned by the people behind the exclusive Soho House, might just be what you're looking for. The 18th century building, once home to the famed Gargoyle Club, has 39 rooms, all categorised by size. A "Broom Cupboard" will set you back £90, while "Bigger" rooms fetch a heftier price tag. Each is decorated with hand-painted Georgian wallpaper and antique furnishings, and the bigger rooms have gorgeous old baths.

Sie planen einen längeren Aufenthalt in Soho? Dann könnte dieses bezaubernde Hotel, dessen Besitzer auch Eigentümer des exklusiven Privatklubs Soho House sind, genau das Richtige für Sie sein. In dem Gebäude aus dem 18. Jahrhundert befand sich einst der berühmte Gargoyle Club. Heute verfügt es über 39 Zimmer, die nach Größen geordnet sind. Eine „Besenkammer" kostet Sie £90, wohingegen größere Zimmer Ihnen einen stolzeren Preis abverlangen. Alle Zimmer sind mit von Hand bemalten Tapeten im georgianischen Stil und antiken Möbeln ausgestattet. Die größeren Zimmer besitzen prachtvolle alte Bäder.

Vous pensez passer un peu de temps dans Soho ? Cet hôtel de charme, propriété du club privé Soho House, pourrait bien proposer ce que vous cherchez. Le bâtiment du XVIIIe siècle, autrefois l'adresse du célèbre Gargoyle Club, dispose de 39 chambres, toutes classées par taille. Un « placard à balais » vous coûtera 90 £, tandis que les chambres de taille « plus généreuse » sont étiquetées à un prix plus considérable. Chaque chambre est décorée avec des meubles antiques et du papier de style géorgien peint à la main, et les chambres les plus grandes comportent de magnifiques baignoires anciennes.

Si tiene previsto pasar mucho tiempo en Soho, este hotelito lleno de encanto, propiedad de los mismos responsables de la exclusiva Soho House, puede que sea justo lo que estaba buscando. El edificio del siglo XVIII albergó en otra época el famoso Gargoyle Club; dispone de 39 habitaciones, todas designadas por tamaño. Un "armario de las escobas" puede costar £90, mientras que habitaciones "más grandes" resultan algo más costosas. Cada una está decorada con papel pintado de estilo georgiano y con mobiliario antiguo. Las habitaciones grandes, además, disponen de preciosas bañeras antiguas.

SANCTUM SOHO HOTEL

20 Warwick Street // Soho
Tel.: +44 (0)20 7292 6100
www.sanctumsoho.com

Bakerloo, Piccadilly lines to Piccadilly Circus,
Bakerloo, Central, Victoria lines to
Oxford Circus

Prices: $$$

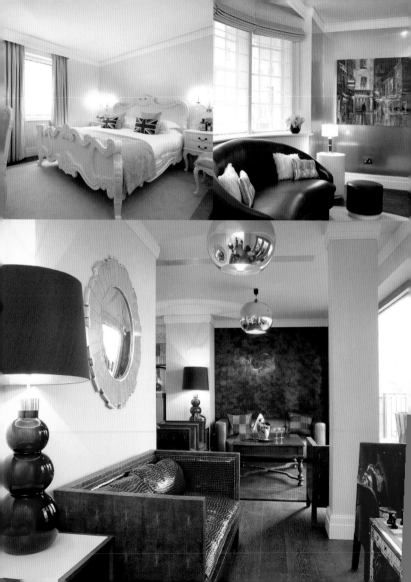

Right in the heart of London's West End, Sanctum Soho is literally that—a blessed place to relax and unwind after the unendingly frenetic pace of a London that is, quite literally, at your doorstep. The hotel boasts chic design that is up-to-the-minute contemporary—despite being housed inside two historic Georgian townhouses on Warwick Street. There's a state of the art private screening room and even an alfresco hydro-spa tucked away in the hotel's stunning roof garden. A sanctuary indeed.

Mitten im Zentrum von Londons West End gelegen hält der Name Sanctum Soho, was er verspricht: ein Ort des Segens, der zum Relaxen und Entspannen einlädt, nachdem man dem hektischen Tempo Londons gefolgt ist, in das man im wahrsten Sinne des Wortes bereits an der Türschwelle eintauchen kann. Das Sanctum Soho wartet mit schickem Design auf, das moderner nicht sein könnte, obwohl das Hotel in zwei historischen georgianischen Stadthäusern in der Warwick Street untergebracht ist. Außerdem verfügt es über einen privaten Vorführraum und sogar über ein Hydro-Spa unter freiem Himmel im atemberaubenden Dachgarten des Hotels. Ein Ort der Zuflucht, wie er im Buche steht.

Situé en plein cœur du West End, Sanctum Soho est effectivement cela : un lieu béni pour se détendre et se relaxer après le rythme effréné de Londres qui est, littéralement, sur le pas de la porte. L'hôtel jouit d'un design chic et d'une contemporanéité dernier cri alors même qu'il est installé dans deux maisons de ville de style géorgien de Warwick Street. Il comporte une salle de projection artistique ultramoderne et même un hydro-spa « alfresco » niché dans le jardin du superbe toit en terrasse de l'hôtel. En effet, c'est un sanctuaire.

En el corazón mismo del West End londinense, Sanctum Soho es lo que promete, un espacio en el que relajarse y escapar a la presión del ritmo frenético del Londres que se abre, literalmente, frente al umbral de la puerta. Pese a ocupar dos históricos edificios de estilo georgiano en Warwick Street, el hotel se ha dotado de un atractivo diseño de impecable modernidad. Cuenta con una sofisticada sala de proyecciones e incluso un spa al aire libre, semioculto en el extraordinario jardín de la azotea. Un verdadero santuario.

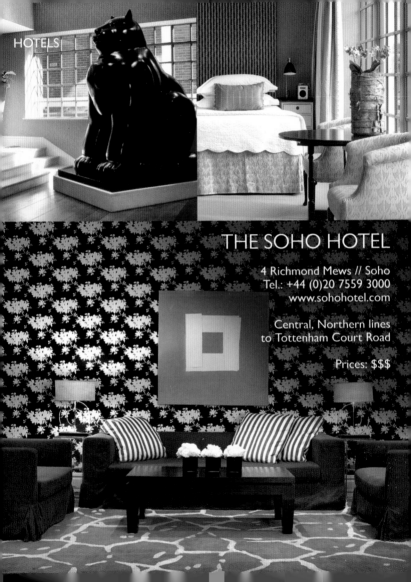

THE SOHO HOTEL

4 Richmond Mews // Soho
Tel.: +44 (0)20 7559 3000
www.sohohotel.com

Central, Northern lines
to Tottenham Court Road

Prices: $$$

Sick of staying in broom closets? Then this place is for you. The rooms at this über-stylish inner-city hotel are some of the loftiest in London, boasting ample space and floor to ceiling windows. Interior designer Kit Kemp has stylishly imagined each of the 91 rooms on offer, all done up differently. There are also four apartments with their own kitchen, sitting room and two bedrooms. And obviously, given its location, there's also a fabulous bar and restaurant. Luxury has never looked this good.

Sie haben die Nase voll von Hotel-Aufenthalten wie in einer Besenkammer? Dann sind Sie hier genau richtig. Die Zimmer in diesem überaus stilvollen Hotel mitten in der Innenstadt gehören zu den vornehmsten Londons und überzeugen mit großzügigem Platz und deckenhohen Fenstern. Innenarchitektin Kit Kemp hat jedes der 91 Zimmer elegant und auf unterschiedliche Art und Weise gestaltet. Außerdem stehen vier Apartments mit eigener Küche, Wohnzimmer und zwei Schlafzimmern zur Verfügung. Angesichts seiner Lage gibt es selbstverständlich auch eine sagenhafte Bar und ein hervorragendes Restaurant. Noch nie hat Luxus so gut ausgesehen.

Vous en avez assez des placards à balai ? Dans ce cas cet endroit est fait pour vous. Les chambres de cet hôtel sophistiqué du centre-ville font parties des plus huppées de Londres. Très spacieuses, elles profitent de grandes baies vitrées. Il y en a 91 et chacune d'entre elles a été élégamment imaginée par l'architecte d'intérieur Kit Kemp et possède son propre design. Quatre appartements ont aussi été aménagés, avec chacun une cuisine, un salon et deux chambres. Et bien entendu, vu son emplacement, l'hôtel comporte aussi un bar et un restaurant fabuleux. Le luxe n'a jamais atteint de tels sommets.

¿Harto de alojarse en el cuarto de las escobas? Puede que este sea su hotel. Las habitaciones de este elegantísimo hotel urbano se cuentan entre las más majestuosas de todo Londres, con amplísimos espacios y auténticos ventanales. El interiorista Kit Kemp ha aplicado toda su imaginación a la decoración individualizada de cada una de las 91 habitaciones disponibles. Cuenta también con cuatro apartamentos con cocina propia, salón y dos dormitorios. Evidentemente, dada su ubicación, dispone también de un excelente bar y restaurante. El lujo nunca ha tenido mejor aspecto.

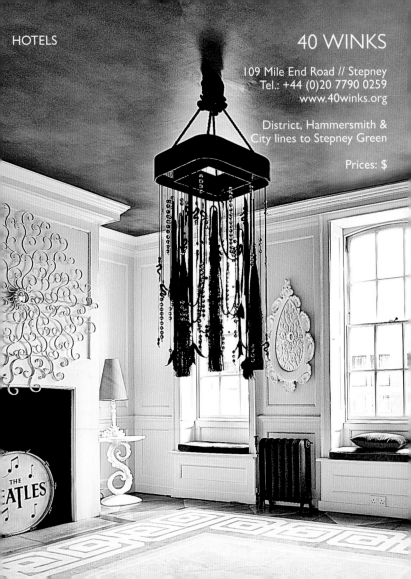

40 WINKS

109 Mile End Road // Stepney
Tel.: +44 (0)20 7790 0259
www.40winks.org

District, Hammersmith &
City lines to Stepney Green

Prices: $

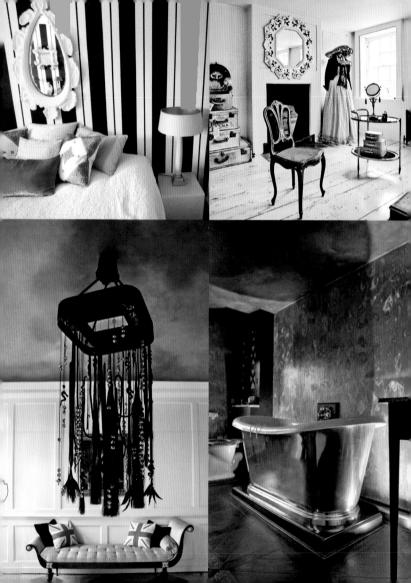

Owned by acclaimed interior designer David Carter, this delightfully stylish Queen Anne townhouse, built in 1717, is a beautiful place to stay. Used as a period location for myriad shoots, David has recently exquisitely designed two of the home's guest bedrooms for short stay use. Aimed primarily at providing visiting stylists, photographers, models and art directors with a place to stay while they're in town, this hotel-alternative offers guests a sublime place to sleep. But book early—there are only two rooms!

Dieses reizende Stadthaus im Queen-Anne-Stil befindet sich im Besitz des gefeierten Innenarchitekten David Carter, wurde 1717 erbaut und verspricht wunderschöne Momente. Zeitweilig werden die Räumlichkeiten für unzählige Foto-Shoots genutzt. Vor Kurzem hat David zwei der Gästezimmer des Hauses auf brillante Art und Weise für Kurzaufenthalte umgestaltet. In erster Linie soll Stylisten, Fotografen, Models und Art Directors, die zu Gast in der Stadt sind, eine Aufenthaltsgelegenheit geboten werden. Diese Hotelalternative bietet ihren Gästen eine außergewöhnliche Übernachtungsmöglichkeit. Sie sollten jedoch rechtzeitig reservieren, denn es gibt nur zwei Zimmer!

Propriété du célèbre architecte d'intérieur David Carter, cette charmante maison de ville de style Queen Anne, construite en 1717, est un lieu de séjour très agréable. Utilisé comme un décor d'époque pour une multitude de tournages, David a récemment décoré deux des chambres d'hôtes de la maison de façon exquise, pour les séjours de courte durée. Destiné principalement à offrir un pied à terre à des stylistes, des photographes, des directeurs artistiques et des mannequins de passage en ville, cette alternative aux hôtels est un lieu sublime pour passer une nuit. Mais réservez à l'avance : il n'y a que deux chambres !

Esta elegantísima mansión de estilo Queen Anne, construida en 1717, es propiedad del destacado interiorista David Carter. Recientemente, David ha diseñado con gusto exquisito dos de los dormitorios de invitados de la casa, utilizado en el rodaje de infinidad de películas de época. Dirigida principalmente a diseñadores, fotógrafos, modelos y directores de arte de paso en la ciudad, esta alternativa a los hoteles ofrece una sublime pernocta. Pero reserve con tiempo: solo hay dos habitaciones.

HAYMARKET HOTEL

1 Suffolk Place // West End
Tel.: +44 (0)20 7470 4000
www.haymarkethotel.com

Bakerloo, Northern lines to Charing Cross,
Bakerloo, Piccadilly lines to Piccadilly Circus

Prices: $$$

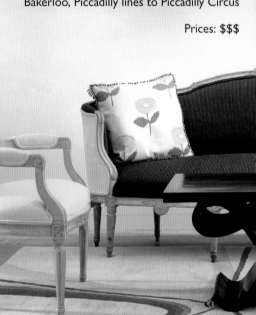

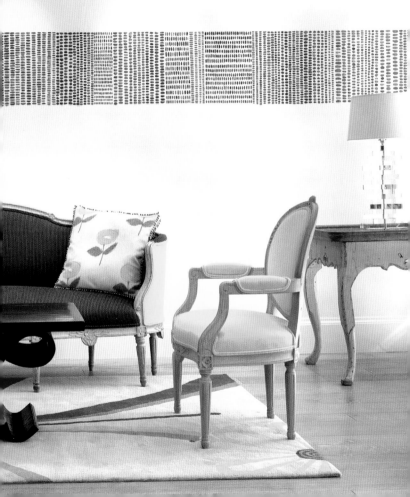

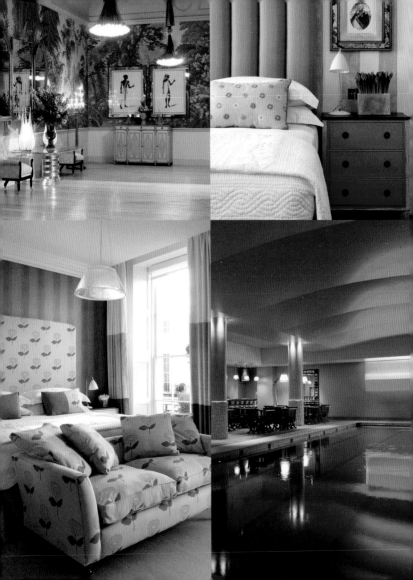

In town for a West End Show? This hotel, next door to the Theatre Royal Haymarket, is the perfect spot to base yourself. But don't discount it as simply a place to doss—one peek inside the gorgeous, vibrantly decorated rooms and you'll be reassessing just how much time you want to spend out of doors. And if you're after something extra special, check your extended entourage into the hotel's charming townhouse next door—it has five double bedrooms! Decadence personified.

Sind Sie in der Stadt, um sich eine West-End-Show anzusehen? Dieses Hotel gleich neben dem Theatre Royal Haymarket ist der perfekte Aufenthaltsort für Sie. Es sollte allerdings nicht als reine Übernachtungsmöglichkeit abgetan werden. Ein Blick in das Innere dieser herrlichen, opulent gestalteten Zimmer und Sie werden die Zeit, die Sie außerhalb dieser vier Wände verbringen wollen, erneut überdenken. Falls Ihnen etwas besonders Außergewöhnliches vorschwebt, dann bringen Sie Ihr Gefolge im bezaubernden Stadthaus des Hotels gleich nebenan unter, denn es verfügt über fünf Doppelzimmer. Dekadenz pur!

Vous êtes en ville pour un spectacle au West End ? Cet hôtel, à côté du Theatre Royal Haymarket, est l'endroit idéal pour vous poser. Mais il ne s'agit pas d'un simple lieu pour « pieuter » : après un coup d'œil à l'intérieur de ses chambres décorées de façon vivante et magnifique, vous réévaluerez le temps que vous compter passer dehors. Et si vous recherchez quelque chose de très spécial, réservez pour votre entourage la charmante maison de ville voisine de l'hôtel : elle dispose de cinq chambres doubles ! La décadence personnifiée.

Quienes acuden a Londres para ver un espectáculo en el West End encontrarán en este hotel, puerta con puerta con el Theatre Royal Haymarket, la base ideal para su estancia. Pero no vea en él solo un lugar en el que pernoctar: basta con ver la vibrante decoración de las habitaciones para replantearse el tiempo que queremos pasar fuera de ellas. Y si lo que busca es algo verdaderamente especial, alójese junto con todos sus acompañantes en el encantador pied à terre que el hotel tiene en el edificio contiguo: ¡dispone de cinco dormitorios dobles! La decadencia personificada.

RESTAURANTS
+CAFÉS

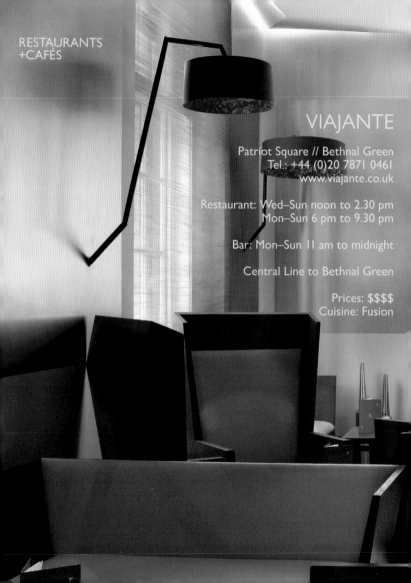

RESTAURANTS
+CAFÉS

VIAJANTE

Patriot Square // Bethnal Green
Tel.: +44 (0)20 7871 0461
www.viajante.co.uk

Restaurant: Wed–Sun noon to 2.30 pm
Mon–Sun 6 pm to 9.30 pm

Bar: Mon–Sun 11 am to midnight

Central Line to Bethnal Green

Prices: $$$$
Cuisine: Fusion

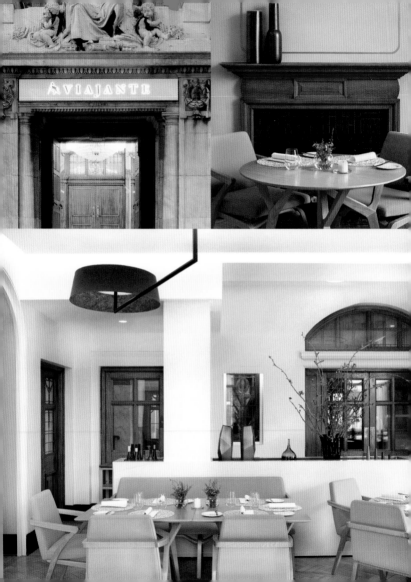

The plates of food arriving at your table are so exquisitely composed, it almost seems criminal to eat them. But once you try the exacting flavours in the bold, exciting dishes prepared by head chef Nuno Mendes, you'll be glad you did. Each plate that leaves the kitchen—which is on show for diners to see their food being prepared—is an absolute revelation. Flavours linger in your mouth demanding a second, third, fourth mouthful. Truly a culinary adventure—and one worth taking.

Die Gerichte auf den Tellern sind so ausnehmend schön angerichtet, dass es beinahe ein Verbrechen wäre, davon zu essen. Sobald Sie jedoch in den Genuss der anspruchsvollen Geschmacksrichtungen der gewagten und aufregenden Gerichte von Chefkoch Nuno Mendes gekommen sind, überwiegt die Freude, dass Sie die Straftat begangen haben. Jeder Teller, der die Küche verlässt, ist eine Offenbarung. Die Zubereitung der Gerichte können die Restaurantgäste in der Küche selbst mitverfolgen. Die Aromen breiten sich in Ihrem Mund aus, der sogleich nach einem weiteren Bissen verlangt. Ein echtes kulinarisches Abenteuer, das Sie nicht verpassen dürfen.

Les plats qui arrivent à votre table sont si délicieusement présentés qu'il semblerait presque criminel d'y toucher. Mais dès que vous aurez tâté des saveurs exigeantes des plats audacieux et affriolants préparés par le Chef Nuno Mendes, vous ne le regretterez pas. Chaque plat qui sort de la cuisine, qui est visible par les clients pour qu'ils puissent voir la préparation de leurs repas, est une véritable révélation. Les saveurs s'attardent dans votre bouche, exigeant une deuxième, troisième, quatrième bouchée… Une véritable aventure culinaire. Et elle en vaut la chandelle !

La composición de los platos que llegan a la mesa es tan exquisita que resulta casi criminal comérselos. Pero una vez comenzamos a probar los exigentes sabores que Nuno Mendes, el chef, consigue insuflar a cada receta, nos alegraremos (y mucho) de haberlo hecho. Cada plato que sale de la cocina (abierta, de modo que los comensales puedan ver la preparación de su comida) es una auténtica revelación. Los sabores permanecen en la boca y reclaman un segundo, un tercero, incluso un cuarto bocado. Una auténtica aventura culinaria; y de las que valen la pena, además.

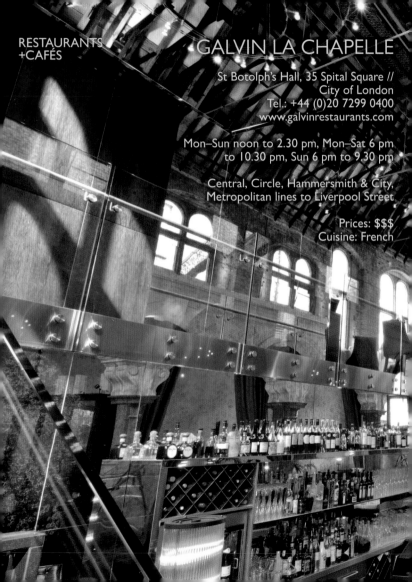

RESTAURANTS
+CAFÉS

GALVIN LA CHAPELLE

St Botolph's Hall, 35 Spital Square //
City of London
Tel.: +44 (0)20 7299 0400
www.galvinrestaurants.com

Mon–Sun noon to 2.30 pm, Mon–Sat 6 pm
to 10.30 pm, Sun 6 pm to 9.30 pm

Central, Circle, Hammersmith & City,
Metropolitan lines to Liverpool Street

Prices: $$$
Cuisine: French

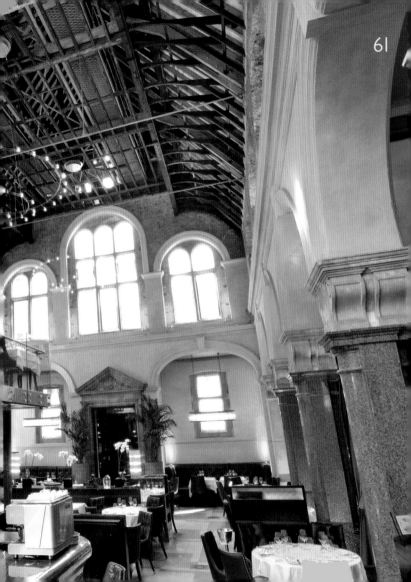

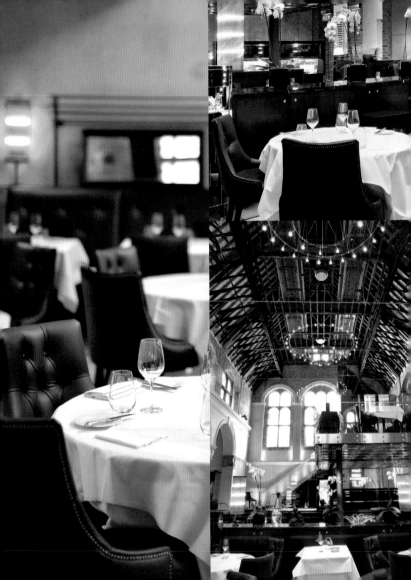

Named the AA Restaurant of the Year 2010, Galvin La Chapelle, housed in the stunning 19th century St Botolph's Hall in Spitalfields, is certainly a destination restaurant. Serving French bistro cuisine in lofty, cathedral-like surrounds, the restaurant boasts fine food and a dizzyingly impressive wine list. The latest restaurant from Chris and Jeff Galvin, who also run the award-winning Galvin Bistrot de Luxe and another at the Hilton Park Lane, is an absolute must-visit for anyone venturing to the City.

Sicherlich nicht verpassen dürfen Sie Galvin La Chapelle, vom britischen Automobilverband AA zum Restaurant des Jahres 2010 gekürt und in St Botolph's Hall, dem überwältigenden Gebäude aus dem 19. Jahrhundert im Stadtteil Spitalfields, untergebracht. In vornehmer Umgebung, die an eine Kathedrale erinnert, bekommt man hier französische Bistro-Küche serviert. Das Restaurant besticht mit Feinkost und einer beeindruckenden Weinkarte. Das neueste Restaurant von Chris und Jeff Galvin, Betreiber des preisgekrönten Galvin Bistrot de Luxe sowie eines weiteren Lokals im Hotel Hilton in der Park Lane, ist ein absolutes Muss für jeden Besucher der Stadt.

Élu restaurant de l'année 2010 par le guide AA, Galvin La Chapelle, logé dans St Botolph, superbe manoir du XIXe siècle de Spitalfields, est certainement un restaurant digne de ce nom. Proposant une cuisine de bistro français dans un décor spacieux aux allures de cathédrale, le restaurant propose une cuisine raffinée et sa carte des vins est impressionnante à vous en faire tourner la tête. Le plus récent des restaurants de Chris et Jeff Galvin, qui tiennent également le primé Galvin Bistrot de Luxe ainsi qu'un autre restaurant à l'Hilton Park Lane, est un must absolu pour toute personne qui s'aventure dans la ville.

Premiado como Restaurante del Año 2010 por la AA, Galvin La Chapelle, situado en el excepcional edificio decimonónico de St Botolph's Hall en Spitalfields, es sin duda un restaurante por el que vale la pena viajar a Londres. Especializado en cocina francesa, servida en salas que asemejan una catedral, el restaurante ofrece alta cocina y una asombrosa carta de vinos. Se trata del más reciente restaurante de Chris y Jeff Galvin, propietarios del galardonado Galvin Bistrot de Luxe y de otro local en Hilton Park Lane, y es de visita casi obligada para quien esté de visita en la ciudad.

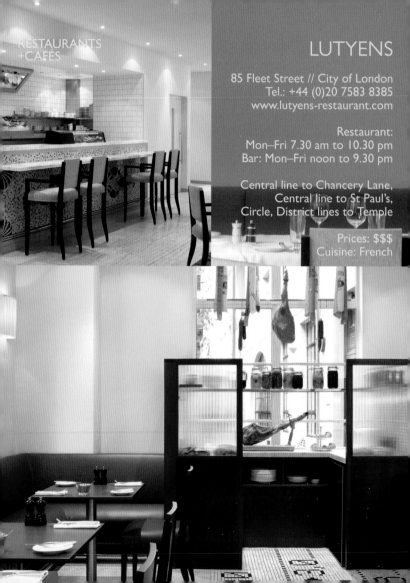

LUTYENS

85 Fleet Street // City of London
Tel.: +44 (0)20 7583 8385
www.lutyens-restaurant.com

Restaurant:
Mon–Fri 7.30 am to 10.30 pm
Bar: Mon–Fri noon to 9.30 pm

Central line to Chancery Lane,
Central line to St Paul's,
Circle, District lines to Temple

Prices: $$$
Cuisine: French

Occupying Fleet Street's famed Reuters/AP Building, designed by Edwin Lutyens in the 1930s, Terence Conran's latest restaurant offering deserves all the good press it's been getting. As you'd expect, the surroundings are suitably stylish, and the food every bit as top-notch as you'd want it to be. There's a sizable bar with charcuterie counter, as well as a 130-seat restaurant, four private dining rooms and a member's club. We're guessing many a power-lunch has graced these premises—and what a great spot to have one.

Terence Conrans neuestes Restaurant befindet sich im berühmten Reuters-/AP-Gebäude in der Fleet Street, das von Edwin Lutyens in den 1930er Jahren entworfen wurde, und es verdient jede einzelne der guten Kritiken, die über dieses Lokal geäußert wurden. Was das angemessen stilvolle Ambiente und das erstklassige Essen betrifft, so werden Ihre Erwartungen keinesfalls enttäuscht. Lutyens beeindruckt mit einer ansehnlichen Bar und einer Fleischtheke sowie einem Restaurant für 130 Gäste, vier privaten Speisesälen und einem Privatklub. Vermutlich ziert so manch ein Geschäftsessen dieses Restaurant und tatsächlich ist Lutyens dafür der ideale Ort.

Installé dans le célèbre bâtiment de Reuters/AP de Fleet Street, conçu par l'architecte anglais Edwin Lutyens dans les années 1930, le dernier restaurant de Terence Conran mérite toute la bonne presse qu'il a reçue. Comme on pourrait s'y attendre, la qualité des repas est à la hauteur de vos espérances et l'élégance du lieu est opportune. Son bar, de taille importante, comprend un comptoir de charcuterie, un restaurant de 130 places, ainsi qu'un club et quatre salles à manger privés. On devine que de nombreux diners d'affaires ont honoré les lieux ; et quel meilleur endroit que celui-ci ?

Instalado en el famoso edificio Reuters/AP Building de Fleet Street, diseñado por Edwin Lutyens en la década de 1930, el más reciente local de restauración de Terence Conran merece todas las aduladoras críticas que ha recibido. Como cabía esperar, el entorno es de lo más elegante, y la comida tan extraordinaria como nos tiene acostumbrados. Cuenta con un mostrador de charcutería de considerable tamaño, así como con un restaurante para 130 comensales, con cuatro salas privadas y un club exclusivo para miembros. A buen seguro, más de un almuerzo de negocios se ha celebrado en el establecimiento: resulta difícil imaginar un entorno más apropiado.

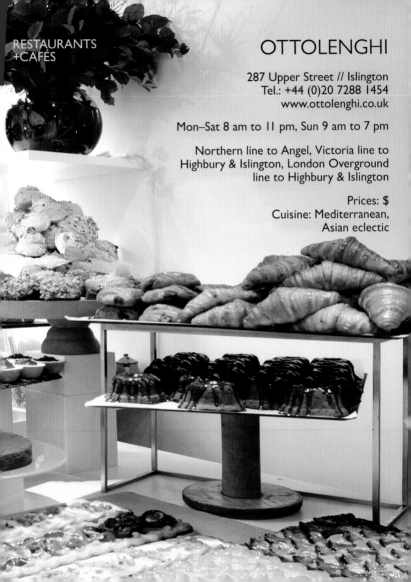

OTTOLENGHI

287 Upper Street // Islington
Tel.: +44 (0)20 7288 1454
www.ottolenghi.co.uk

Mon–Sat 8 am to 11 pm, Sun 9 am to 7 pm

Northern line to Angel, Victoria line to
Highbury & Islington, London Overground
line to Highbury & Islington

Prices: $
Cuisine: Mediterranean,
Asian eclectic

Towering piles of meringue, all manner of cakes and biscuits, bowls of salads so delicious you'll want to stop what you're doing immediately and head inside for a sample. Yes, one look at the window display at Islington's famed Ottolenghi, and you know you're in for one hell of a culinary experience. People travel from all over the world to sample the gorgeous food on offer at this stylishly simple eatery, thanks, in part, to Yotam Ottolenghi's popular cookbooks. You won't be disappointed.

Berge von Baisers, jede erdenkliche Sorte von Kuchen und Keksen, Schüsseln mit Salaten so köstlich, dass sie für eine Kostprobe alles stehen und liegen lassen werden. Ein Blick in die Auslage des berühmten Ottolenghi in Islington genügt und Ihnen wird klar, dass Ihnen ein unglaubliches kulinarisches Erlebnis bevorsteht. Zum Teil aufgrund der beliebten Kochbücher von Yotam Ottolenghi reisen Menschen aus aller Welt an, um die vorzüglichen Gerichte in diesem stilvoll schlichten Lokal zu kosten. Sie werden nicht enttäuscht sein!

Des piles de meringue imposantes, toutes sortes de gâteaux et de biscuits, des bols de salades si délicieux que vous serez pris d'une envie immédiate de tout abandonner pour foncer les goûter. En effet, un coup d'œil à la célèbre vitrine d'Ottolenghi du quartier d'Islington, et vous savez que vous êtes partant pour une expérience culinaire d'enfer. On vient du monde entier pour goûter les plats superbes que propose cet établissement de restauration élégamment simple, grâce, en partie, aux livres de recettes populaires de Yotam Ottolenghi. Vous ne serez pas déçus.

Inmensas pilas de merengues, pasteles y galletas de todo tipo, cuencos con ensaladas tan deliciosas que le entran a uno ganas de dejarlo todo para entrar a probarlas… Sí, basta un vistazo al escaparate del famoso Ottolenghi de Islington para saber que nos espera una extraordinaria experiencia gastronómica. Los clientes llegan de todo el mundo para probar los maravillosos platos que se sirven en este elegantemente modesto local, gracias en parte a la popularidad de los libros de cocina de Yotam Ottolenghi. Nunca decepciona.

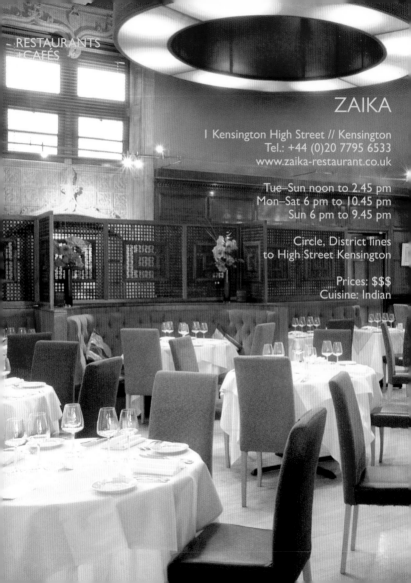

ZAIKA

1 Kensington High Street // Kensington
Tel.: +44 (0)20 7795 6533
www.zaika-restaurant.co.uk

Tue–Sun noon to 2.45 pm
Mon–Sat 6 pm to 10.45 pm
Sun 6 pm to 9.45 pm

Circle, District lines
to High Street Kensington

Prices: $$$
Cuisine: Indian

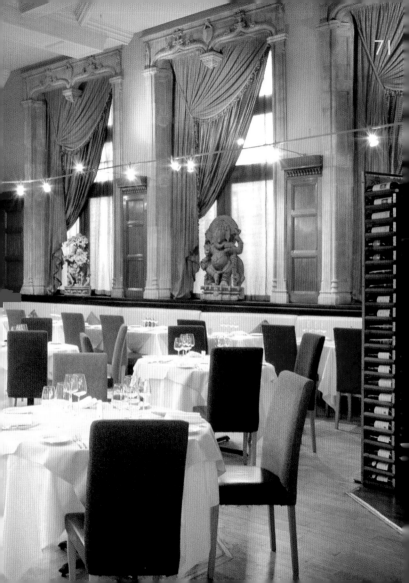

With curry being Britain's official national dish, it's little wonder London boasts some of the finest Indian restaurants in the country. Housed in an old bank building on Kensington High Street, the opulently-styled Zaika is one such restaurant. Modern Indian is served imaginatively in impressive surroundings, making that bright-orange Rogan Josh you're tempted to grab between pub and home look startlingly sad by comparison. Zaika was one of the first Indian restaurants to gain a Michelin star—and it continues to impress.

Da Curry Großbritanniens offizielles Nationalgericht ist, verwundert es kaum, dass London mit einigen der besten indischen Restaurants des Landes aufwartet. Eines davon ist das opulent eingerichtete Zaika, das in einem ehemaligen Bankgebäude in der Kensington High Street untergebracht ist. Auf einfallsreiche Art werden in diesem eindrucksvollen Ambiente moderne indische Gerichte serviert, die sogar das leuchtend orangefarbene Rogan Josh, das Sie auf dem Nachhauseweg anlacht, vergleichsweise unspektakulär aussehen lassen. Zaika ist das erste indische Restaurant, dem ein Michelin-Stern verliehen wurde, und sein Erfolg reißt nicht ab.

Le curry étant le plat national officiel de la Grande-Bretagne, il n'y a rien d'étonnant à ce que Londres, sa petite merveille, possède certains des meilleurs restaurants indiens du pays. Installé dans une ancienne banque de Kensington High Street, le Zaika, restaurant au style opulent, en est un exemple. La cuisine indienne moderne est servie avec imagination dans un décor impressionnant, ce qui rend le plat orange criard de Rogan Josh que vous étiez tentés d'emporter à la maison à votre retour du pub, étonnamment triste en comparaison. Zaika a été l'un des premiers restaurants indiens à recevoir une étoile au Michelin. Et il continue de nous impressionner.

Visto que los currys son el plato oficial del Reino Unido, no puede sorprender que en Londres se encuentren algunos de los mejores restaurantes indios del país. Alojado en un antiguo edificio bancario de Kensington High Street, el suntuoso Zaika es uno de ellos. En su impresionante interior se sirve comida india contemporánea llena de imaginación que hace palidecer en comparación cualquiera de las mediocridades que acostumbramos a comprar en los take away de camino a casa. Zaika fue uno de los primeros restaurantes indios en obtener una estrella Michelin, y a día de hoy sigue impresionando a su clientela.

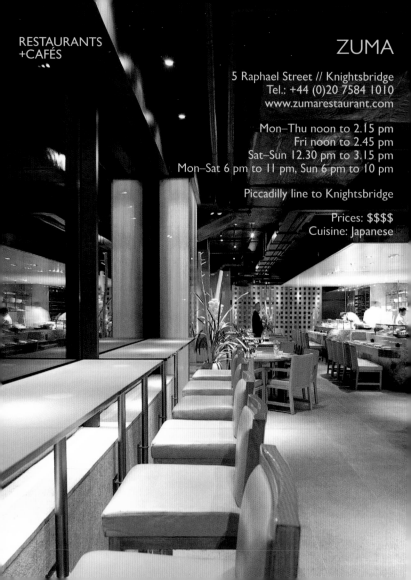

RESTAURANTS
+CAFÉS

ZUMA

5 Raphael Street // Knightsbridge
Tel.: +44 (0)20 7584 1010
www.zumarestaurant.com

Mon–Thu noon to 2.15 pm
Fri noon to 2.45 pm
Sat–Sun 12.30 pm to 3.15 pm
Mon–Sat 6 pm to 11 pm, Sun 6 pm to 10 pm

Piccadilly line to Knightsbridge

Prices: $$$$
Cuisine: Japanese

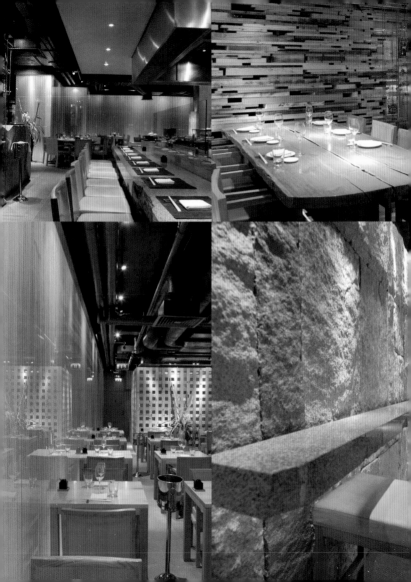

Japanese dining reaches dizzying new heights at this exclusive venue. The food, which boasts opulent offerings like wagyu beef and sea urchin, is beautifully executed, and will have fans wanting to return again and again. But it's not just the dishes that will take your breath away—the interior of this unique venue is just as awe-inspiring. Designed by Tokyo architects Super Potato, under the direction of designer Noriyoshi Muramatsu, the mix of stone, steel and wood works a treat.

In diesem außergewöhnlichen Lokal steigt die japanische Küche zu schwindelerregenden neuen Höhen auf. Die liebevoll angerichteten Speisen, zu denen auch Wagyu-Rind und Seeigel gehören, werden für Begeisterung und eine baldige Wiederkehr der Gäste sorgen. Aber nicht nur das Essen ist atemberaubend, sondern auch die Innenraumgestaltung dieses einzigartigen Orts hinterlässt einen ebenso großen Eindruck. Das Design, ein harmonischer Mix aus Stein, Stahl und Holz, geht auf die aus Tokio stammenden Architekten Super Potato unter der Leitung des Designers Noriyoshi Muramatsu zurück.

La cuisine japonaise atteint de nouveaux sommets vertigineux dans ce lieu privilégié. Les repas, qui proposent des plats opulents, comme le bœuf wagyu ou les oursins, sont magnifiquement exécutés, et leurs fans ne cessent d'y revenir, encore et encore. Mais ce ne sont pas seulement les plats qui vous couperont le souffle : l'intérieur de ce lieu unique est tout aussi impressionnant. Conçu par les architectes de Tokyo Super Potato, sous la direction du designer Noriyoshi Muramatsu, le mélange de pierre, d'acier et de bois du décor fait partie du plaisir.

La gastronomía japonesa alcanza nuevas y estratosféricas cotas en este exclusivísimo local. La oferta culinaria, que abarca la ternera wagyu y los erizos de mar, es excepcional y encandila a quienes la prueban. Pero no solo la carta resulta arrebatadora: los interiores de este establecimiento único resultan igual de asombrosos. Diseñada por el despacho de arquitectos Super Potato de Tokio, bajo la dirección del diseñador Noriyoshi Muramatsu, la combinación de piedra, acero y madera tiene un efecto extraordinario.

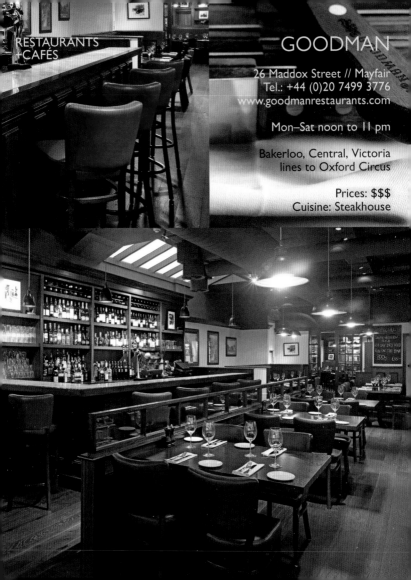

GOODMAN

26 Maddox Street // Mayfair
Tel.: +44 (0)20 7499 3776
www.goodmanrestaurants.com

Mon–Sat noon to 11 pm

Bakerloo, Central, Victoria
lines to Oxford Circus

Prices: $$$
Cuisine: Steakhouse

Searching out the best steak in the world has become an obsession for more than a few globally-minded food lovers. So let's save you the time—and the money—by suggesting there's only one place worth visiting during your trip to London, and that's Goodman. The folks at this meaty spot source only the finest prime beef, aged to perfection in their in-house Dry Ageing Room. Every steak is cooked just as you'd want it to be and there's an impressive wine list to boot. Meat heaven.

Die Suche nach dem besten Steak der Welt ist für mehr als ein paar weltoffene Feinschmecker zur Besessenheit geworden. Also sparen wir Ihnen Zeit und Geld und behaupten, es gibt nur einen Ort, der einen Abstecher während ihres Besuchs in London wert ist, und das ist Goodman. Hier wird ausschließlich hochwertigstes Rindfleisch bezogen, das bis zur Perfektion im hauseigenen Reiferaum ruht. Jedes Steak wird Ihrem Geschmack entsprechend zubereitet und auch die Weinkarte ist nicht zu verachten. Willkommen im Fleisch-Paradies!

Goûter le meilleur steak du monde est devenu une obsession qui dépasse le cercle des gourmets conscients des problèmes de globalisation. Alors gagnez du temps (et de l'argent) : s'il n'y a qu'un seul endroit à visiter pendant votre voyage à Londres, c'est Goodman Mayfair. Les patrons de ce spot pour amateurs de viande ne sélectionnent que le meilleur bœuf, vieilli à la perfection dans leur chambre de maturation à sec. Chaque steak est cuit exactement comme vous l'aimez et ils ont une impressionnante carte des vins. Le paradis de la viande !

Para más de un aficionado a la gastronomía, buscar el mejor bistec del mundo se ha convertido poco menos que en una obsesión. Para ahorrarles tiempo y dinero, quede aquí dicho que a ese respecto solo vale la pena pasar por un restaurante durante su estancia en Londres, y ese es Goodman. Los responsables del local seleccionan los mejores cortes de ternera, que acondicionan a la perfección en su propia cámara de maduración en seco. Cada bistec se prepara tal y como desea el comensal, y la oferta se redondea con una impresionante carta de vinos. El paraíso para carnívoros.

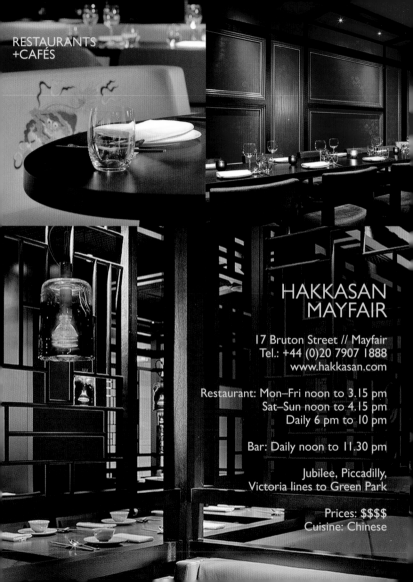

HAKKASAN
MAYFAIR

17 Bruton Street // Mayfair
Tel.: +44 (0)20 7907 1888
www.hakkasan.com

Restaurant: Mon–Fri noon to 3.15 pm
Sat–Sun noon to 4.15 pm
Daily 6 pm to 10 pm

Bar: Daily noon to 11.30 pm

Jubilee, Piccadilly,
Victoria lines to Green Park

Prices: $$$$
Cuisine: Chinese

Seeking a truly memorable meal? Look no further than Michelin-starred Chinese restaurant, Hakkasan Mayfair. This is the second Hakkasan to open in London and it's every bit as opulent as its forebear. The interior is conceived by Paris-based designer Guillaume Richard, and matches exquisitely with the deluxe modern Cantonese cuisine on offer. Waitresses serve food wearing red dresses designed by Diane von Furstenberg. This is one seriously stylish, seriously sublime restaurant. An extraordinary experience.

Lust auf ein wahrhaft unvergessliches Essen? Dann sind Sie beim Michelin-Stern gekürten chinesischen Restaurant Hakkasan Mayfair genau an der richtigen Adresse. Hierbei handelt es sich bereits um das zweite Hakkasan, das in London seine Türen öffnet, und es steht seinem Vorfahren in Sachen Opulenz keineswegs nach. Die Innenraumgestaltung ist dem in Paris ansässigen Designer Guillaume Richard zu verdanken und passt ausgezeichnet zu den modernen kantonesischen Luxusgerichten. Die Bedienungen tragen rote Kleider, die von Diane von Furstenberg entworfen wurden. Dieses Restaurant könnte stilvoller und grandioser nicht sein. Ein außergewöhnliches Erlebnis erwartet Sie!

RANKIN'S SPECIAL TIP

I love the food here, and the cocktails are delicious.

Vous voulez un repas dont vous vous souviendrez longtemps ? Filez tout droit au Hakkasan Mayfair, le restaurant chinois étoilé au Michelin. Il s'agit du deuxième Hakkasan qui ouvre à Londres et il est tout aussi somptueux que son grand frère. L'intérieur a été conçu par le designer Guillaume Richard, établi à Paris, et il se marie de manière exquise à la cuisine cantonaise moderne qu'ils proposent. Les serveuses portent de robes rouges conçues par Diane von Furstenberg. Il s'agit d'un restaurant sublime, très tendance. Une expérience extraordinaire.

¿Busca una comida verdaderamente memorable? No tiene más que acercarse a Hakkasan Mayfair, el restaurante chino galardonado por la guía Michelin. Se trata del segundo Hakkasan que abre en Londres, y no desmerece en nada del primero. El interior ha sido concebido por el diseñador parisino Guillaume Richard y se combina exquisitamente con la lujosa oferta de gastronomía cantonesa moderna del local. Las camareras sirven la comida ataviadas con vestidos rojos diseñados por Diane von Furstenberg. Estamos hablando de un restaurante con auténtica elegancia y encanto. Una experiencia extraordinaria.

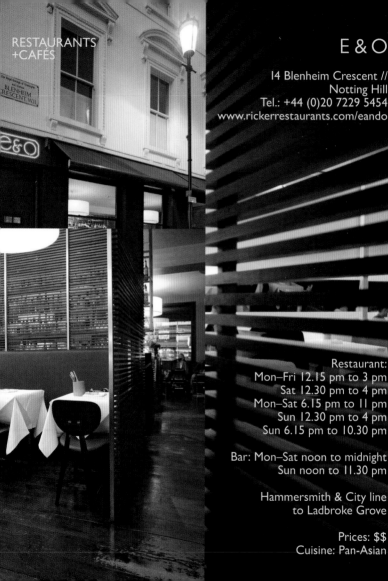

E & O

14 Blenheim Crescent //
Notting Hill
Tel.: +44 (0)20 7229 5454
www.rickerrestaurants.com/eando

Restaurant:
Mon–Fri 12.15 pm to 3 pm
Sat 12.30 pm to 4 pm
Mon–Sat 6.15 pm to 11 pm
Sun 12.30 pm to 4 pm
Sun 6.15 pm to 10.30 pm

Bar: Mon–Sat noon to midnight
Sun noon to 11.30 pm

Hammersmith & City line
to Ladbroke Grove

Prices: $$
Cuisine: Pan-Asian

A trip to E & O, literally standing for "Eastern and Oriental", should be on every foodie's to-do list. Tucked away in a buzzy corner of Notting Hill, this stylish restaurant serves up exquisitely crafted pan-Asian cuisine. Make sure you take your camera—the food looks so good, you'll want to get a photo first before devouring it. House favourites chilli salt squid and the gyoza are top notch, and there's a fabulous bar where you can enjoy beautifully crafted cocktails before dinner.

Einen Besuch im E & O, das für „Eastern and Oriental" steht, sollte sich kein Feinschmecker entgehen lassen. Versteckt in einer lebhaften Ecke Notting Hills, bietet dieses stilvolle Restaurant seinen Gästen exquisite panasiatische Küche. Nehmen Sie Ihren Fotoapparat mit, denn das Essen sieht so verlockend aus, dass Sie es sicher zuerst bildlich festhalten wollen, bevor Sie es sich einverleiben. Die Spezialitäten des Hauses, Chili-Salz-Tintenfisch und Gyoza, sind erstklassig, und an der legendären Bar kommen Sie vor dem Abendessen in den Genuss zauberhaft zubereiteter Cocktails.

Une visite à « Eastern & Oriental » devrait être au programme de tous les gourmands. Niché dans un coin de Notting Hill grouillant d'activités, ce restaurant élégant sert une cuisine panasiatique exquise et recherchée. Emportez votre appareil photo : les repas sont si attrayants que vous aurez envie de prendre une photo avant de les dévorer. Les spécialités de la maison, les calmars salés au piment et le gyoza, sont excellents, et avant le dîner, vous pourrez déguster des cocktails magnifiques dans un bar fabuleux.

En la lista de cosas por hacer de todo amante de la gastronomía debe figurar una visita a E & O, literalmente "Eastern and Oriental". Agazapado en una concurrida esquina de Notting Hill, este elegante restaurante sirve cocina panasiática de impecable realización. Asegúrese de llevar su cámara consigo: la comida tiene tan buen aspecto que querrá inmortalizarla antes de devorarla. Algunos platos recomendados: calamares al chili y gyuza. Tiene también un magnífico bar en el que disfrutar de cócteles sabiamente mezclados antes de la cena.

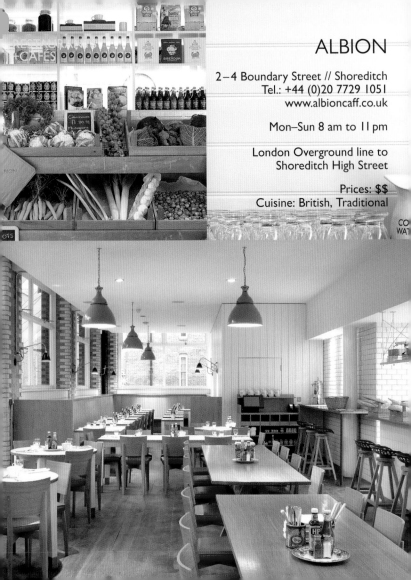

ALBION

2–4 Boundary Street // Shoreditch
Tel.: +44 (0)20 7729 1051
www.albioncaff.co.uk

Mon–Sun 8 am to 11 pm

London Overground line to
Shoreditch High Street

Prices: $$
Cuisine: British, Traditional

This caff-style eatery serves up traditional British food—but there's nothing ordinary about the way they do it. Fish and chips, steak and kidney pie, potted shrimp—it's all here, and just as you remember it. The difference is, Albion use the very best ingredients and make sure that each and every piece of grub that appears on your plate is the best it can be. They also have an amazing on-site bakery and shop. Just like your favourite neighbourhood caff—'cept better!

Dieses Restaurant erinnert durch seine Aufmachung an ein Café und führt traditionelle britische Gerichte auf seiner Speisekarte. Deren Zubereitung ist jedoch alles andere als gewöhnlich. Hier finden Sie alles, von Fish and Chips, über Steak and Kidney Pie, bis hin zu Potted Shrimps, genauso, wie man es in London erwartet. Der Unterschied liegt darin, dass Albion die besten Zutaten auswählt und jeder Bissen auf Ihrem Teller tadellos ist. Außerdem gibt es auch eine tolle hauseigene Bäckerei sowie einen kleinen Laden. Wie in Ihrem Lieblingscafé um die Ecke, nur besser!

RANKIN'S SPECIAL TIP

Albion on Boundary Street, pure British food, doesn't pretend to be anything else. Does the simple things well.

Ce café-resto sert une cuisine typiquement britannique. Mais attention, rien d'ordinaire dans la façon dont ils s'y prennent. Fish and chips, steak and kidney pie, potted shrimp… Tout y est, exactement comme dans les photos de vos cours d'anglais. La différence, c'est qu'Albion n'utilise que les meilleurs ingrédients et s'assure que chaque élément du frichti qui atterrit dans votre assiette soit la meilleure qui puisse être. L'endroit fait également office de boulangerie – excellente ! – et de boutique. Exactement comme votre café local préféré. Mais en mieux !

En este restaurante-cafetería se sirve comida británica tradicional, pero nada de lo que allí se hace puede considerarse habitual. Fish and chips, empanada de carne y riñón, gambas en nuez moscada… todo lo que esperábamos encontrar en Londres está aquí. La diferencia estriba en que en Albion se utilizan los mejores ingredientes y se esfuerzan en que la comida que aparece en nuestro plato sea la mejor posible. Tienen también una asombroso horno de pan con tienda propia. Como la cafetería de la esquina. ¡Pero muchísimo mejor!

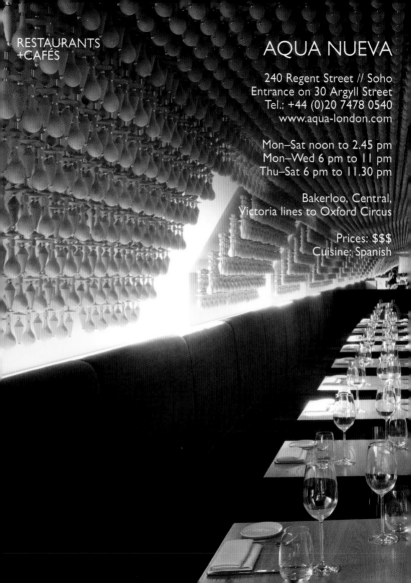

AQUA NUEVA

240 Regent Street // Soho
Entrance on 30 Argyll Street
Tel.: +44 (0)20 7478 0540
www.aqua-london.com

Mon–Sat noon to 2.45 pm
Mon–Wed 6 pm to 11 pm
Thu–Sat 6 pm to 11.30 pm

Bakerloo, Central,
Victoria lines to Oxford Circus

Prices: $$$
Cuisine: Spanish

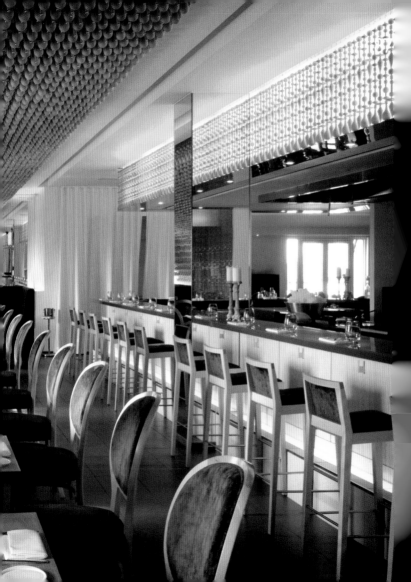

You can't get more typically London than aqua nueva's Regent Street location. Perched atop the iconic former Dickens & Jones department store, the restaurant boasts stunning views across the West End. But don't expect anything too traditional from this British restyling of the worldwide Aqua Restaurant Group. aqua nueva serves up contemporarily Spanish fare from Northern Spain in decidedly modern surroundings. Head chef Alberto Hernandez—who trained with Ferran Adrià at famed elBulli—presides, so you know it's going to be good.

Es ist unmöglich, London auf noch typischere Art zu erleben als im aqua nueva in der Regent Street. Auf dem Dach des ehemaligen faszinierenden Kaufhauses Dickens & Jones beeindruckt das Restaurant mit seiner atemberaubenden Aussicht über das West End. Erwarten Sie jedoch nicht allzu viel Traditionelles von diesem britischen Neuzugang der weltweiten Aqua Restaurant Group. Bei aqua nueva genießt man in ausgesprochen trendigem Ambiente moderne Speisen aus der nordspanischen Küche. Hier hat Chefkoch Alberto Hernandez das Sagen, der durch die Schule von Starkoch Ferran Adrià in dessen berühmtem Restaurant elBulli gegangen ist. Enttäuschungen sind also von vornherein ausgeschlossen.

Il n'y a pas plus londonien que le site d'aqua nueva sur Regent Street. Perché au sommet des anciens grands magasins emblématiques de Dickens & Jones, le restaurant offre une vue imprenable sur le West End. Mais n'attendez pas quelque chose de trop traditionnel de cette adaptation britannique du groupe mondial de restauration Aqua. aqua nueva sert une cuisine contemporaine du nord de l'Espagne dans un cadre résolument moderne. Formé auprès de Ferran Adrià au célèbre elBulli, le chef Alberto Hernandez dirige les cuisines, de sorte que côté assiette, pas d'inquiétude !

Nada hay más típicamente londinense que Regent Street, la zona en el que se ha instalado aqua nueva. Situado encima de lo que en tiempos fueran los legendarios grandes almacenes Dickens & Jones, el restaurante ofrece vistas deslumbrantes sobre el West End. Pero no esperen nada tradicional en este local, nueva encarnación en Gran Bretaña del grupo de restauración Aqua. aqua nueva presenta recetas contemporáneas inspiradas en el norte de España en un entorno decididamente moderno. Alberto Hernández, jefe de cocina formado en el famoso elBulli a las órdenes de Ferran Adrià, se ocupa de todo, toda una garantía de calidad.

SHOPS

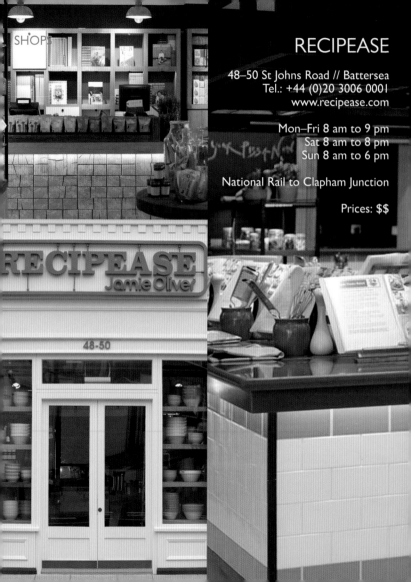

RECIPEASE

48–50 St Johns Road // Battersea
Tel.: +44 (0)20 3006 0001
www.recipease.com

Mon–Fri 8 am to 9 pm
Sat 8 am to 8 pm
Sun 8 am to 6 pm

National Rail to Clapham Junction

Prices: $$

He's now as synonymous with British food as jellied eels and pies and mash, so it stands to reason that Britain's premier kitchen geezer, Jamie Oliver, should open his own cooking school and shop. Recipease in Clapham Junction stocks everything you might need for your kitchen, including Jamie's own brand of ready-meals. There's a yum eat-in and take-out cafe specialising in breakfast and lunch, and they also run cooking classes for everyone from beginners to kitchen whizzes. Pucker tucker, mate!

Wie Aal in Aspik, Pastete und Kartoffelbrei so ist auch er nicht länger aus der britischen Küche wegzudenken. Es liegt also nahe, dass Großbritanniens kulinarischer Volksheld, Jamie Oliver, seine eigene Kochschule und seinen eigenen Laden eröffnet. Recipease am Bahnhof Clapham Junction bietet alles, was Sie in Ihrer Küche benötigen, einschließlich Jamies eigener Marke an Fertiggerichten. Außerdem gibt es ein ausgezeichnetes Café, in dem Sie die Frühstücks- und Mittagsspezialitäten vor Ort oder auch zum Mitnehmen genießen können. Sowohl Anfänger als auch Kochprofis können hier an den Kochstunden teilnehmen. Um es mit Jamies Worten zu sagen: „Pucker tucker! [Tolles Essen!]"

Il est devenu un symbole de la nourriture britannique, autant que les anguilles en gelée, les pies ou les pommes de terre écrasées ; il allait donc de soi que le top cuistot du « frichti » à l'anglaise, Jamie Oliver, ouvre son magasin et sa propre école de cuisine. Situé à Clapham Junction, Recipease (une contraction de « Recipes at ease », les recettes faciles pour tous) offre tout ce dont votre cuisine a besoin, y compris le prêt-à-consommer de la propre marque de Jamie. Un coin de café offre un menu appétissant de plats à déguster sur place ou à emporter, spécialisés dans les petits-déjeuners et déjeuners. Des cours de cuisine sont aussi proposés, ouverts à tous, des débutants aux plus doués. Comme dirait Jamie, « Pucker tucker, mate! » (Ça, mon pote, c'est de la bouffe !).

El nombre de Jamie Oliver está en la actualidad tan indisolublemente asociado a la gastronomía británica como el fish and chips, de modo que no deja de ser lógico que el más desenfadado de los chefs británicos haya abierto su propia tienda-escuela de cocina. Recipease, situada en Clapham Junction, tiene a la venta todo cuanto hace falta en la cocina, incluidas las comidas precocinadas del propio Jamie. Cuenta con una suculenta cafetería en la que comer u ordenar comidas para llevar, especializada en desayunos y almuerzos, y ofrece también clases de cocina para todos, desde principiantes hasta avezados cocineros. ¡A mover el bigote!

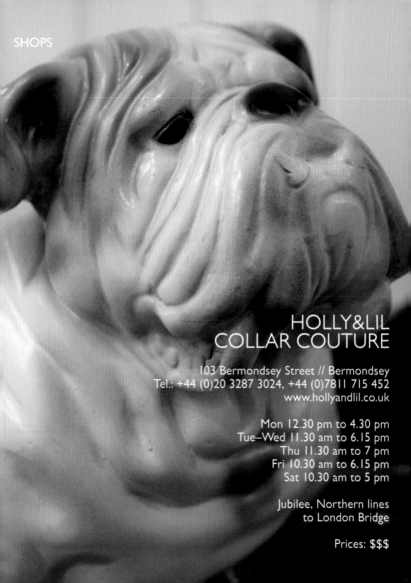

HOLLY&LIL
COLLAR COUTURE

103 Bermondsey Street // Bermondsey
Tel.: +44 (0)20 3287 3024, +44 (0)7811 715 452
www.hollyandlil.co.uk

Mon 12.30 pm to 4.30 pm
Tue–Wed 11.30 am to 6.15 pm
Thu 11.30 am to 7 pm
Fri 10.30 am to 6.15 pm
Sat 10.30 am to 5 pm

Jubilee, Northern lines
to London Bridge

Prices: $$$

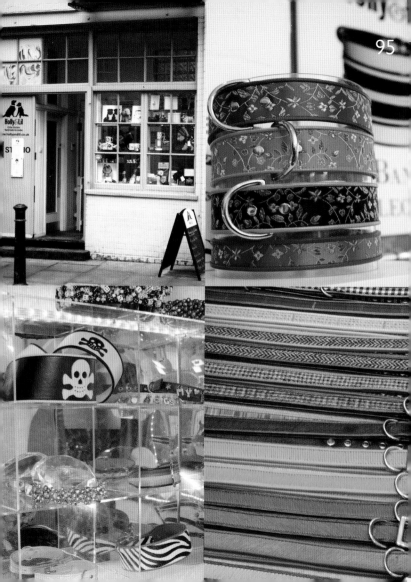

What is Holly&Lil, we hear you ask? Well, the question should really be—who are Holly and Lil? The answer? Two rather lovely black dogs, whose owners began musing one day about the fact that there weren't a great deal of fashionable, good quality leather dog collars and accessories for sale. Fast forward six years and they're now handcrafting and stocking their own. Head to their gorgeous shop in SE1 to check out the ever-changing collection—and meet the mutts in person!

Was ist Holly&Lil, fragen Sie? Nun, die Frage sollte besser lauten: „Wer sind Holly und Lil?" Die Antwort: Zwei entzückende schwarze Hunde, deren Besitzer eines Tages der Gedanke kam, dass es im Handel kaum Auswahl an modischen Lederhalsbändern guter Qualität und Accessoires gab. Sechs Jahre später stellen sie nun ihre eigenen Produkte her und verkaufen diese auch selbst. Besuchen Sie ihren umwerfenden Laden im Südosten Londons, bewundern Sie die stetig wandelnden Kollektionen und treffen Sie die Vierbeiner persönlich!

Nous vous entendons déjà demander « C'est quoi Holly&Lil ? ». En réalité, la question devrait plutôt être « Qui sont Holly et Lil ? ». La réponse ? Deux chiens noirs plutôt charmants, dont les propriétaires se firent un jour la réflexion que la mode ne s'intéressait pas beaucoup au problème de l'élégance et la qualité des colliers pour chien en cuir et des autres accessoires à la vente. Six ans après, ils possèdent leur fond de commerce, qui ne cesse de s'agrandir, et vendent leurs articles artisanaux. Allez visiter leur superbe boutique sur Bermondsey Street, au centre de Londres, pour voir cette collection en constante évolution et rencontrer les toutous en personne !

¿Qué es Holly&Lil, oímos preguntar? La pregunta debería ser más bien quiénes son Holly y Lil? ¿La respuesta? Dos bonitos perros negros, cuyos propietarios se pusieron a maquinar tras constatar que no existía verdadera calidad en la oferta de collares y demás accesorios para perros. Seis años más tarde, siguen fabricando artesanalmente y vendiendo sus creaciones. Una visita a su espectacular tienda en SE1 nos permite conocer sus siempre cambiantes colecciones y también a sus dos perros.

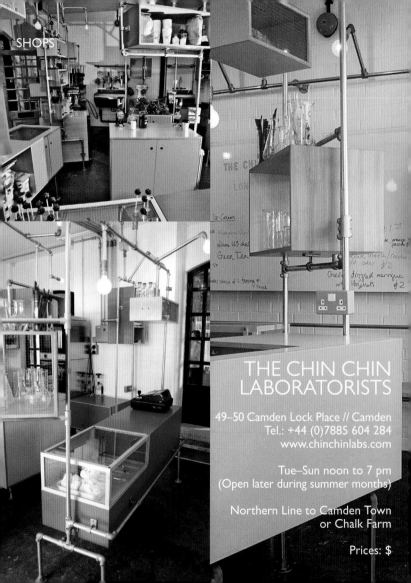

THE CHIN CHIN
LABORATORISTS

49–50 Camden Lock Place // Camden
Tel.: +44 (0)7885 604 284
www.chinchinlabs.com

Tue–Sun noon to 7 pm
(Open later during summer months)

Northern Line to Camden Town
or Chalk Farm

Prices: $

Europe's only liquid nitrogen ice-cream shop opened in Camden in 2010 and has had visitors ooing and aahing ever since. The owners of this shop pride themselves on having successfully reinvented an old favourite, appropriating the ingenious liquid nitrogen freezing techniques favoured by the likes of Heston Blumenthal and Ferran Adrià. Its performance art meets cryogenics at this quirky ice-cream lab, with flavours like basil and crunchy olive oil, Earl Grey and Victoria sponge cake on offer. Delish!

Europas einziger Flüssigstickstoff-Eiscreme-Shop eröffnete im Jahr 2010 seine Türen in Camden, und seitdem ebbt das Erstaunen der Besucher nicht ab. Die Besitzer rühmen sich, einen Renner vergangener Zeiten neu erfunden zu haben, indem sie sich die genialen Flüssigstickstoff-Gefriertechniken angeeignet haben, die bereits Heston Blumenthal, Ferran Adrià und ihresgleichen begeistert haben. In diesem eigentümlichen Eiscreme-Labor trifft Kunst auf Tieftemperaturtechnik, und das Angebot besticht mit Geschmacksrichtungen wie Basilikum und Knusper-Olivenöl oder Earl Grey und Victoria-Biskuitkuchen. Köstlich!

Seul vendeur de glace européen utilisant l'azote liquide, le magasin de Camden a ouvert ses portes en 2010. Depuis, on n'y entend que des « Aaah ! » et des « Oooh ! ». Les propriétaires de ce magasin sont fiers d'avoir su réinventer un vieux favori, en se réappropriant les techniques ingénieuses de congélation à l'azote liquide recommandées par des experts comme Heston Blumenthal et Ferran Adrià. Dans cet excentrique laboratoire de la crème glacée, l'art moderne rencontre la cryogénie, produisant un choix de parfums incluant basilic, huile d'olive croquante, Earl Grey ainsi qu'une génoise à en mourir. Du délice à l'état pur !

La única heladería de nitrógeno líquido en Europa fue inaugurada en Camden en 2010 y maravilla desde entonces a todos quienes la visitan. Los propietarios se precian de haber reinventado un clásico de la gastronomía, apropiándose para ello de las ingeniosas técnicas de congelación con nitrógeno líquido utilizadas por chefs como Heston Blumenthal y Ferran Adrià. En este excéntrico laboratorio del helado, el performance art se combina con las técnicas criogénicas para crear sabores como albahaca y aceituna crujiente, o Earl Grey y tarta de bizcocho. Riquísimo.

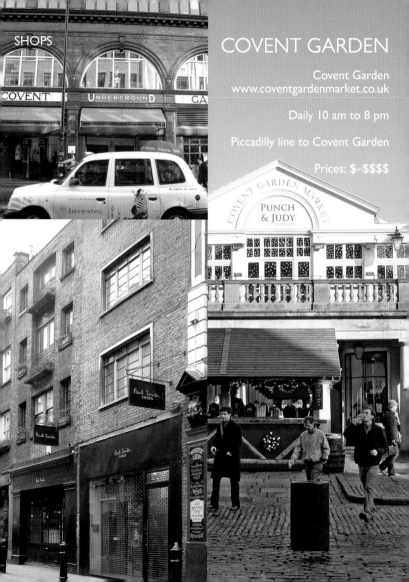

SHOPS

COVENT GARDEN

Covent Garden
www.coventgardenmarket.co.uk

Daily 10 am to 8 pm

Piccadilly line to Covent Garden

Prices: $–$$$$

Awright, Guvnah? Covent Garden, historically London's central fruit and veg market, was once awash with these sorts of phrases, bandied about by Cockney barrow boys selling their wares. These days, visitors are more likely to associate the area with West End shows or with the throngs of tourists who gather at its central square—also home to the London Transport Museum—to watch the array of street performances. Seven Dials, to the north, is home to a selection of trendy independent stores, and well worth a look.

„Awright, Guvnah?" Diese oder ähnliche Sätze bekam man häufig von den im Cockney-Dialekt sprechenden Straßenhändlern auf Londons ursprünglichem Obst- und Gemüsemarkt Covent Garden zu hören. Heute verbindet man diesen Stadtteil eher mit West-End-Shows oder Scharen von Touristen, die sich auf dem zentralen Platz tummeln und sich die zahlreichen Straßenkünstler ansehen. Hier befindet sich auch das Londoner Verkehrsmuseum. Am Verkehrsknotenpunkt Seven Dials im Norden sind eine Vielzahl trendiger kleinerer Läden einen Besuch wert.

Awright, Guvnah ? (salutation en cockney londonien). Covent Garden était historiquement le marché principal des fruits et légumes de Londres. Autrefois, ce type de phrase pouvait être entendu à tous les coins de rue par des Cockney boys qui vendaient leurs marchandises sur des charrettes. De nos jours, les visiteurs associeraient plutôt l'endroit aux spectacles du West End ou aux foules de touristes qui se pressent sur le square central (où se trouve également le London Transport Museum) pour profiter des nombreux spectacles de rue. Au nord, Seven Dials vaut le détour, qui abrite une sélection de magasins indépendants à la mode.

"Awright, Guvnah?" En Covent Garden, históricamente el mercado central de frutas y verduras de la ciudad, frases como esta eran habituales en boca de los cockneys que vendían el género desde sus carretas. Hoy en día, el visitante asocia esta zona de la ciudad con los espectáculos del West End o las masas de turistas que se reúnen en la plaza central (sede también del London Transport Museum) para presenciar espectáculos callejeros de todo tipo. Seven Dials, algo más al norte, acoge una serie de tiendecitas independientes muy de moda: todas ellas merecen una visita.

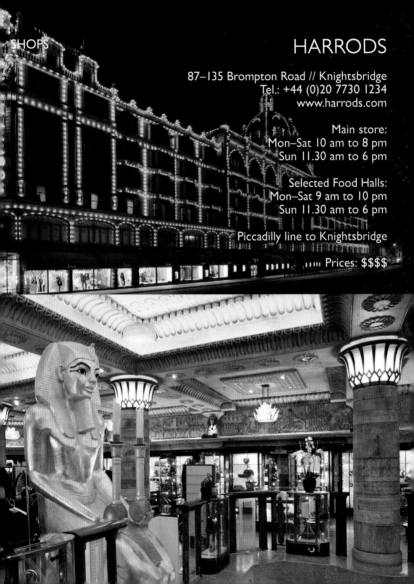

HARRODS

87–135 Brompton Road // Knightsbridge
Tel.: +44 (0)20 7730 1234
www.harrods.com

Main store:
Mon–Sat 10 am to 8 pm
Sun 11.30 am to 6 pm

Selected Food Halls:
Mon–Sat 9 am to 10 pm
Sun 11.30 am to 6 pm

Piccadilly line to Knightsbridge

Prices: $$$$

The green bags, the twinkling Christmas lights, the famous food hall—Harrods hardly needs description, so synonymous is it with London's shopping scene. More than just a department store, this historical shopping venue first opened on its current site in 1851 and has come to represent Britain all over the world thanks to its clever marketing and unique branding. In 2010, it was sold by its previous owner, the enigmatic Mohamed Fayed, to Qatar Holdings for a staggering £1.5 billion.

Die grünen Taschen, die glitzernden Weihnachtslichter, die berühmte Lebensmittelabteilung – Harrods muss man kaum beschreiben, so sehr setzt man es mit Londons Shopping-Szene gleich. Harrods ist mehr als nur ein Warenhaus. Das historische Einkaufsparadies öffnete an seinem heutigen Standort zum ersten Mal 1851 die Türen und ist seitdem dank seines intelligenten Marketings und seiner einmaligen Markenentwicklung auf der ganzen Welt zu einem Inbegriff für Großbritannien geworden. 2010 wurde Harrods von seinem früheren Besitzer, dem mysteriösen Mohamed Fayed, an Qatar Holdings für atemberaubende £1,5 Milliarden verkauft.

Les célèbres sacs verts, le scintillement des lumières de Noël, le fameux food hall… Plus besoin de présenter Harrods, tellement ses galeries sont synonymes de « temple du shopping » à Londres. Plus qu'un simple grand magasin, ce lieu de shopping historique a ouvert ses portes pour la toute première fois en 1851 sur son emplacement actuel avant de devenir, grâce à son marketing intelligent et à sa stratégie de marque unique, un symbole de la Grande-Bretagne à travers le monde. En 2010, son ancien propriétaire, l'énigmatique Mohamed Fayed, l'a vendu à Qatar Holdings pour un paiement échelonné de 1,5 milliards de livres sterling (soit 1,7 milliards d'euros au moment de la vente).

Las bolsas verdes, los destellos de las luces navideñas, la famosa sección de alimentación… Harrods apenas precisa descripción. Baste decir que su nombre es sinónimo de salir de compras por Londres. El histórico establecimiento, mucho más que unos simples grandes almacenes, abrió sus puertas en 1851 y gracias a inteligentes campañas de marketing y de creación de marca ha acabado representando al Reino Unido en todo el mundo. En 2010, su enigmático propietario Mohamed Fayed vendió la propiedad a Qatar Holdings por la astronómica suma de 1 500 millones de libras esterlinas.

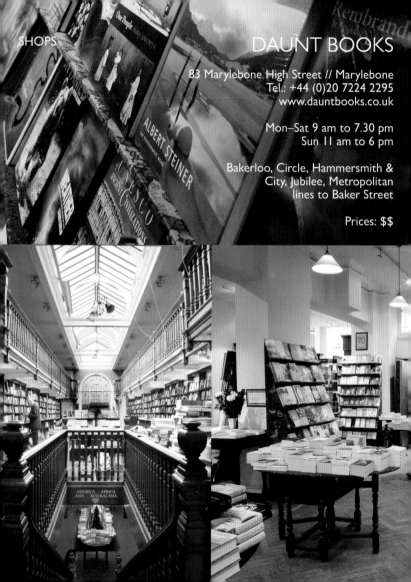

There's nothing more pleasant than whiling away an hour or two settled snugly within the peaceful oasis that is Daunt Books. The original—there are now four other branches—can be found on Marylebone High Street and is housed within a beautiful old Edwardian building, replete with oak bookcases stacked, quite literally, to the ceiling. Specialising in travel literature, Daunt pride themselves on old-fashioned service and extensive knowledge. The store's owner refuses to sell books he wouldn't read himself—props to him.

Nichts ist angenehmer, als sich eine oder zwei Stunden gemütlich die Zeit in der friedlichen Oase Daunt Books zu vertreiben. Heute gibt es bereits vier Niederlassungen, das Original befindet sich jedoch in der Marylebone High Street in einem wunderschönen Gebäude aus der Zeit von König Edward VII. Hier reihen sich endlos Bücherregale aus Eichenholz aneinander und reichen buchstäblich bis unter die Decke. Daunt Books hat sich auf Reiseliteratur spezialisiert und ist stolz auf seinen freundlichen Service und das umfassende Fachwissen. Der Inhaber bietet hier kein Buch zum Verkauf an, das er nicht selbst lesen würde. Das verdient Respekt!

This is one of the last independent book stores left—I always come out of the shop with a pile of books that I never intended to buy.

Il n'y a rien de plus agréable que passer une heure ou deux installé confortablement dans ce havre de paix qu'est Daunt Books. Le magasin du bouquiniste originel – il y en a maintenant quatre autres – se trouve sur Marylebone High Street dans un immeuble édouardien magnifique, littéralement tapissé jusqu'au plafond d'étagères en chêne. Spécialisé dans la littérature de voyage, Daunt Books tire sa fierté d'un service à l'ancienne, basé sur une connaissance approfondie. Le propriétaire du magasin refuse de vendre des livres qu'il ne lirait pas lui-même – ce qui est tout à son honneur.

Nada hay más agradable que dedicar una o dos horas a perderse en el oasis de paz que constituye Daunt Books. El local original (actualmente cuenta con cuatro sucursales) se encuentra en un hermoso edificio eduardiano de Marylebone High Street; en su interior, las estanterías de roble están cargadas de libros hasta el techo. Literalmente. Especializada en literatura de viajes, Daunt se enorgullece de su servicio chapado a la antigua y de sus extensos conocimientos. El propietario de la tienda se niega a vender libros que él no esté dispuesto a leer, un gesto que le honra.

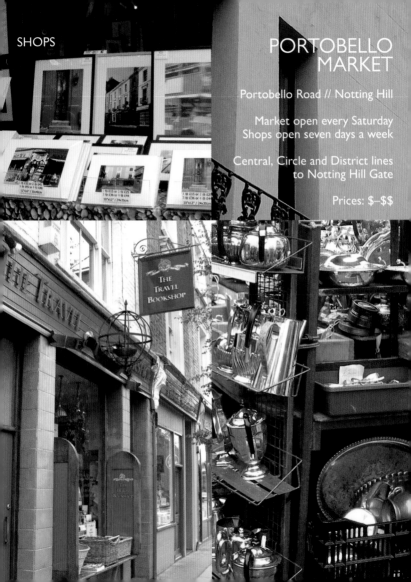

PORTOBELLO MARKET

Portobello Road // Notting Hill

Market open every Saturday
Shops open seven days a week

Central, Circle and District lines
to Notting Hill Gate

Prices: $–$$

THE TRAVEL BOOKSHOP

Although it reached global audiences through the hugely popular Brit flick Notting Hill, way before Hugh Grant and his floppy fringe made Portobello Market famous, this London institution was attracting visitors from as far back as the 19th century. Originally a fresh produce market on Portobello Road, it began to sell antiques in the 1960s and now has a little bit of everything. Antiques, crafts, fresh food, clothes—you name it, and chances are someone's selling it on a rickety trestle along this historic stretch of street.

Obwohl der Portobello Market erst wirklich durch Hugh Grant und seine verstrubbelten Haare in dem britischen Film Notting Hill weltbekannt wurde, zog diese Londoner Gegend bereits seit dem 19. Jahrhundert Besucher an. Ursprünglich befand sich dort ein Markt für Frischwaren, seit den 1960er Jahren wurden Antiquitäten verkauft. Heute findet man von allem ein bisschen: Antiquitäten, Kunsthandwerk, Frischwaren, Kleidung – Sie brauchen es nur auszusprechen und es bestehen gute Chancen, dass sich dafür entlang dieses historischen Straßenabschnitts ein Verkäufer hinter einem klapprigen Holzstand findet.

Bien qu'il n'ait connu un succès mondial qu'après la sortie de la comédie britannique « Coup de foudre à Notting Hill » et bien avant que Hugh Grant et sa mèche ne rendent cette institution londonienne célèbre, Portobello Market attirait déjà un flot continuel de visiteurs depuis le XIXe siècle. À l'origine un marché de produits frais établi sur Portobello Road, on a commencé à y vendre des antiquités dans les années 1960 et on y trouve maintenant un peu de tout. Antiquités, artisanat, produits frais, vêtements… Quoi que vous cherchiez, il y a des chances que vous le trouviez sur un étalage branlant de ce bout de rue historique.

Pese a que la fama global le llegó a través de la popularísima película Notting Hill, mucho antes de que el rutilante flequillo de Hugh Grant pusiese Portobello Market en boca de todos esta institución londinense llevaba desde el siglo XIX atrayendo a visitantes de todo tipo. En el que fuera mercado de productos frescos en Portobello Road empezaron a venderse antigüedades en la década de 1960, y actualmente ofrece un poco de todo. Antigüedades, artesanías, alimentación, ropa…busques lo que busques, lo más seguro es que lo encuentres a la venta sobre una desvencijada mesilla en este histórico tramo de calle.

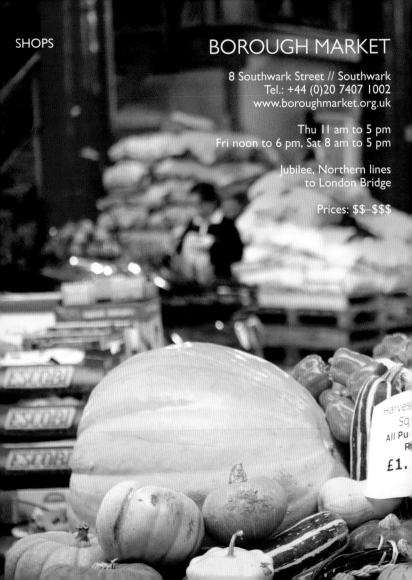

SHOPS

BOROUGH MARKET

8 Southwark Street // Southwark
Tel.: +44 (0)20 7407 1002
www.boroughmarket.org.uk

Thu 11 am to 5 pm
Fri noon to 6 pm, Sat 8 am to 5 pm

Jubilee, Northern lines
to London Bridge

Prices: $$–$$$

Harves
Sq
All Pu
R
£1.

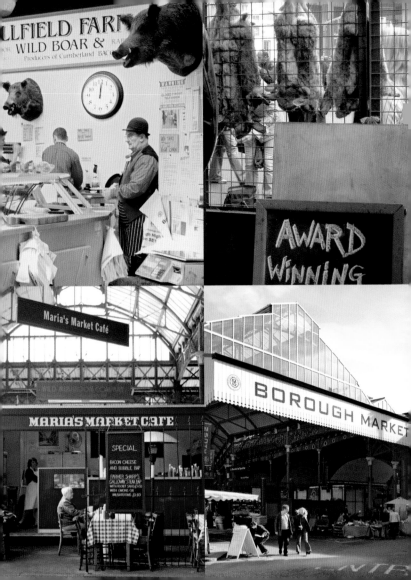

Wheels of cheese piled high, fish so fresh they're practically swimming away, loaves of bread stacked neatly in rows and every kind of deliciousness you can imagine—welcome to foodie heaven. The origins of Borough Market hark back to the 13th century, and people have been coming to this spot to sell their produce ever since. Open Thursdays, Fridays and Saturdays, this delicious corner of London should be on every food-lover's itinerary. Pack an empty stomach and get ready to munch.

Stapelweise Käse, Fische, die vor lauter Frische praktisch wegzuschwimmen scheinen, ordentlich aneinandergereihte Brotlaibe und allerlei Köstlichkeiten, die man sich nur vorstellen kann: Willkommen im Feinschmeckerparadies! Der Ursprung von Borough Market geht bis in das 13. Jahrhundert zurück. Seitdem kommen Händler an diesen Ort, um donnerstags, freitags und samstags ihre Produkte anzupreisen. Diese appetitanregende Ecke Londons sollten sich Liebhaber des guten Essens keinesfalls entgehen lassen. Kommen Sie mit leerem Magen und seien Sie auf allerlei Leckereien gefasst.

De hautes piles de meules de fromage, du poisson tellement frais qu'il vous échappe des doigts, des files bien rangées de miches de pain, et toutes sortes de délices auxquels on s'attend : bienvenue au paradis de la bonne chère ! Depuis ses origines au XIIIe siècle, les marchands de Borough Market viennent y négocier leurs produits. Ouvert les jeudis, vendredis et samedis, ce délicieux coin de Londres devrait être un passage obligé pour chaque gourmand qui se respecte. Partez l'estomac vide et préparez-vous à dévorer.

Pilas y pilas de ruedas de queso, pescado tan fresco que poco le falta para salir nadando, hogazas de pan pulcramente alineadas y todos los manjares que uno sea capaz de imaginar… Bienvenidos al paraíso de la gastronomía. Los orígenes de Borough Market se remontan al siglo XIII, y desde entonces siempre ha habido aquí gente queriendo vender su género. Abierto jueves, viernes y sábados, este delicioso rincón de Londres debería figurar en el itinerario de todos los amantes de la comida. Para ir con apetito y ánimos de saciarse.

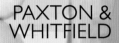

PAXTON & WHITFIELD

93 Jermyn Street // St James's
Tel.: +44 (0)20 7930 0259
www.paxtonandwhitfield.co.uk

Mon–Sat 9.30 am to 6 pm

Bakerloo, Piccadilly lines
to Piccadilly Circus

Prices: $$

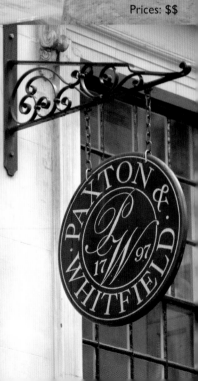

What these fromage-o-philes don't know about cheese, quite frankly, just isn't worth knowing. Established in St James's for over 200 years—and in their current premises for over 100—a visit to their very cosy, very cheesy shop is a must for any lover of the wheel. The origins of this amazing shop date all the way back to 1742. In 1850 they were appointed chief cheesemonger to HM Queen Victoria— and they continue to provide cheese to the Royal family.

Was diese Käseliebhaber nicht über Käse wissen, lohnt sich nicht zu wissen. Vor über 200 Jahren wurde dieser überaus gemütliche und „käsige" Laden in St James's gegründet und befindet sich seit über 100 Jahren an seinem heutigen Standort. Ein Besuch ist für alle Freunde des Käselaibs ganz einfach ein Muss. Der Ursprung dieses außergewöhnlichen Ladens geht bis auf das Jahr 1742 zurück. 1850 wurden die Inhaber zum Hauptkäsehändler von Ihrer Majestät Königin Victoria ernannt und noch heute versorgen sie die königliche Familie mit Käse.

Il n'y a franchement pas grand chose que ces fromagers ne connaissent pas sur le sujet. Ils sont établis à St James's depuis plus de 200 ans et installés dans leurs locaux actuels depuis plus d'un siècle. Une visite de leur crémerie très cosy, très cheesy, est un must pour tout Français qui se respecte. Les origines de cette boutique étonnante remontent jusqu'à 1742. En 1850, ils furent nommés fromagers officiels en chef de Sa Majesté la Reine Victoria ; et aujourd'hui encore, ils continuent d'approvisionner la famille royale.

Si hay algo que estos especialistas no conocen acerca de los quesos es porque no merece la pena saberse. Establecidos en St James's desde hace más de 200 años y en su actual establecimiento desde hace más de cien, la visita a este templo del queso es de obligado cumplimiento para todo gourmet. Los orígenes de esta increíble tienda se remontan a 1742. En 1850 fueron nombrados proveedores de Su Majestad la Reina Victoria, y aún hoy siguen suministrando los quesos de la familia real.

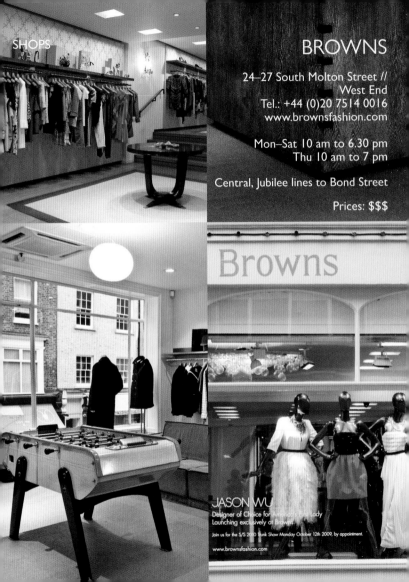

SHOPS

BROWNS

24–27 South Molton Street //
West End
Tel.: +44 (0)20 7514 0016
www.brownsfashion.com

Mon–Sat 10 am to 6.30 pm
Thu 10 am to 7 pm

Central, Jubilee lines to Bond Street

Prices: $$$

Browns

JASON WU
Designer of Choice for America's First Lady
Launching exclusively at Browns

Join us for the S/S 2010 Trunk Show Monday October 12th 2009, by appointment.

www.brownsfashion.com

If directional, forward-thinking fashion is your thing, then Browns is your place. Joan Burstein and her husband Sydney opened the store in the 1970s—and they've been at the forefront of British fashion ever since. Known for their large window displays, they've launched the careers of many a fashion luminary, including John Galliano, Alexander McQueen and Hussein Chalayan—all given coveted window space at the store. But be warned—high fashion doesn't come cheap, so bring plenty of kerching!

Sie mögen richtungsweisende, innovative Mode? Dann ist Browns genau der richtige Ort. Joan Burstein und ihr Ehemann Sydney eröffneten den Laden in den 1970er Jahren und bewegen sich seitdem an der Spitze der britischen Modewelt. Sie sind bekannt für ihre umfangreiche Schaufensterdekoration und verhalfen mehr als nur einer Modegröße zur Karriere, darunter auch John Galliano, Alexander McQueen und Hussein Chalayan – ihnen allen wurde einer der begehrten Schaufensterplätze des Ladens gewährt. Aber seien Sie gewarnt: High Fashion hat ihren Preis, also statten Sie Ihr Portemonnaie entsprechend aus.

Si vous suivez les tendances de la mode avant-gardiste, alors Browns est faite pour vous. Joan Burstein et son mari Sydney ont ouvert le magasin dans les années 1970, et sont restés depuis à la pointe de la mode britannique. Connus pour leurs larges vitrines, ils ont lancé la carrière de nombre de créateurs illustres, y compris John Galliano, Alexander McQueen et Hussein Chalayan : tous ont profité de l'espace convoité des vitrines de cette célèbre boutique. Mais attention ! La haute couture n'est pas à la portée de tous, alors ne sortez pas sans une carte de crédit en platine !

Si lo tuyo es la moda progresiva y creadora de tendencias, en Browns encontrarás lo que buscas. Joan Burstein y su marido Sydney abrieron el local en la década de los setenta y se han mantenido desde entonces en la vanguardia de la moda británica. Conocidos por sus gigantescos escaparates, han sido la piedra de toque de más de una luminaria de la moda, entre ellas John Galliano, Alexander McQueen y Hussein Chalayan; todos ellos han visto allí expuestas sus creaciones. Una advertencia: lo mejor de la moda no resulta nada barato, así que más vale tener la tarjeta de crédito a mano.

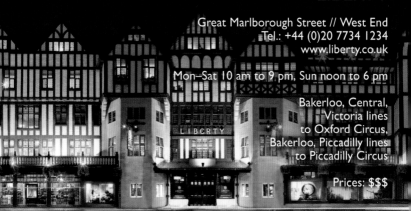

SHOPS

LIBERTY

Great Marlborough Street // West End
Tel.: +44 (0)20 7734 1234
www.liberty.co.uk

Mon–Sat 10 am to 9 pm, Sun noon to 6 pm

Bakerloo, Central,
Victoria lines
to Oxford Circus,
Bakerloo, Piccadilly lines
to Piccadilly Circus

Prices: $$$

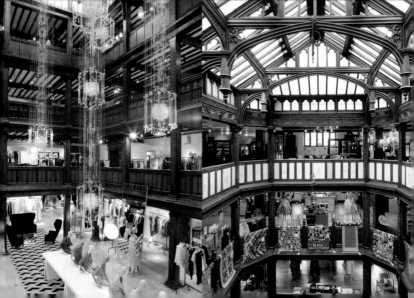

Sick of the same-same predictability of high street shopping on Oxford Street? A quick trip round the corner to the beautiful and historic Liberty & Co will sort you right out. This Grade II listed mock-Tudor building has become a Mecca for those seeking beautiful fashion, gorgeous home wares, and, of course, those trademark Liberty products. Their extensive collection of hand-bags and accessories are to die for. But if budget is your concern, there's also a gorgeously inexpensive gift shop.

Haben Sie die immer wiederkehrende Voraussagbarkeit des Ein-kaufsstraßenerlebnisses in der Oxford Street satt? Gleich um die Ecke wird Sie das wunderschöne und historische Liberty & Co wieder versöhnlich stimmen. Dieses denkmalgeschützte Gebäude im Stil der Tudor-Architektur hat sich zum Mekka für Liebhaber wunderschöner Mode, traumhafter Haushaltswaren und natürlich der Liberty-Markenprodukte entwickelt. Die umfangreiche Kollek-tion an Handtaschen und Accessoires ist zum Niederknien. Ver-fügen Sie nicht über das erforderliche Kleingeld, dann wartet auf Sie ein umwerfender Geschenkartikelladen mit niedrigen Preisen.

RANKIN'S SPECIAL TIP

It's a department store that feels like a boutique.

Êtes-vous lassé de la monotonie prévisible des magasins de la rue commerçante d'Oxford Street ? Un petit tour au coin de la rue, du côté du magnifique bâtiment historique de Liberty & Co, devrait vous satisfaire. Ce bâtiment classé de style Tudor est devenu la Mecque des fanatiques de mode somptueuse, d'articles de maison superbes, et, bien sûr, des produits de la marque Liberty. Leur vaste collection de sacs à main et acces-soires est à mourir. Mais si votre budget est serré, vous pourrez trouver votre bonheur dans la boutique cadeaux à petits prix.

¡Hartos de lo predecibles que se han vuelto las tiendas de Oxford Street? Una esquina más allá, en el hermoso e histórico Liberty & Co, encontraréis lo que buscáis. Este pastiche de estilo Tudor (declarado edificio de interés cultural) se ha convertido en una auténtica meca para quienes buscan moda extraordinaria, espectacular menage del ho-gar y por supuesto los productos Liberty marca de la casa. Su extensa colección de bolsos y accesorios es simplemente divina. Si el presupues-to no da para grandes alegrías, el establecimiento cuenta también con

MAP N° **35**

una tienda de regalos asequibles pero no por ello menos fabulosos.

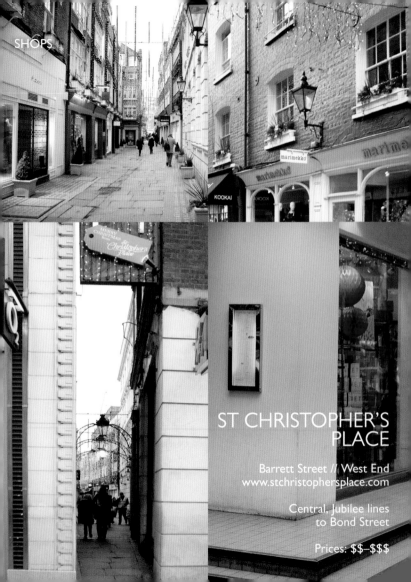

ST CHRISTOPHER'S PLACE

Barrett Street // West End
www.stchristophersplace.com

Central, Jubilee lines
to Bond Street

Prices: $$–$$$

Like having all your favourite designers in the same spot but loathe the thought of visiting one of those bustling mega-malls? St Christopher's Place, in the heart of London's busy West End, is the perfect antidote. Brands like Ghost, Reiss, Whistles, Mulberry, Kew and Kookaï are all here, quietly and stylishly vying for your attention in the selection of narrow cobbled streets. There are also plenty of fabulous and affordable places to eat, with kerbside dining the order of the day.

Wäre es nicht einfach zu schön, wenn alle Ihre Lieblings-Designer am selben Ort zu finden wären und Sie nicht eine dieser überlaufenen Riesen-Shopping-Malls aufsuchen müssten? St Christopher's Place, im Herzen von Londons geschäftigem West End, ist die perfekte Lösung. Marken wie Ghost, Reiss, Whistles, Mulberry, Kew und Kookaï, sie alle sind hier versammelt und buhlen in einer Vielzahl von schmalen gepflasterten Straßen still und stilvoll um Ihre Aufmerksamkeit. Außerdem gibt es hier viele ausgezeichnete und preiswerte Möglichkeiten zum Essen und Trinken, wo man das Tagesmenü an Tischen auf dem Bürgersteig serviert bekommt.

Vous aimez l'idée d'un endroit qui rassemble tous vos créateurs préférés, mais visiter l'un de ces méga centres commerciaux vous fait horreur ? St Christopher's Place, au cœur du quartier vivant du West End de Londres, est le parfait antidote. Toutes les marques, de Ghost à Reiss, Whistles, Mulberry, Kew ou encore Kookaï, y sont présentes, guettant votre attention dans une atmosphère tranquille et stylée, facilitée par les rues étroites et pavées. Le quartier regorge également de petits restos fabuleux et abordables, avec plat du jour à consommer en terrasse.

¿Te atrae la idea de tener a tus diseñadores favoritos en un mismo espacio, pero aborreces la simple idea de acudir a un bullicioso megacentro comercial? St Christopher's Place, en pleno corazón del West End londinense, es el antídoto perfecto. Marcas como Ghost, Reiss, Whistles, Mulberry, Kew y Kookaï están aquí representadas y compiten elegantemente por tu atención a ambos lados de las estrechas callecitas adoquinadas. Dispone también de magníficos y asequibles locales de comida, y es habitual disfrutar del almuerzo en las mesas situadas en la acera.

CLUBS, LOUNGES +BARS

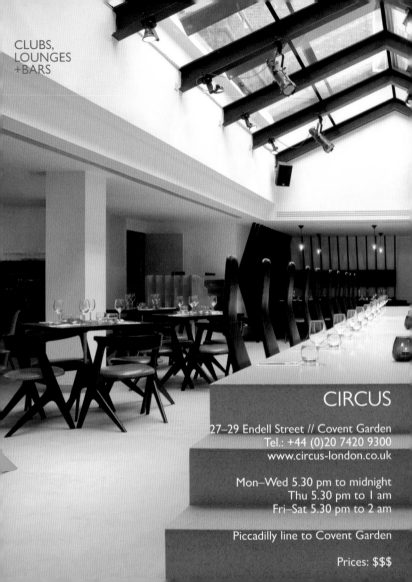

CLUBS,
LOUNGES
+BARS

CIRCUS

27–29 Endell Street // Covent Garden
Tel.: +44 (0)20 7420 9300
www.circus-london.co.uk

Mon–Wed 5.30 pm to midnight
Thu 5.30 pm to 1 am
Fri–Sat 5.30 pm to 2 am

Piccadilly line to Covent Garden

Prices: $$$

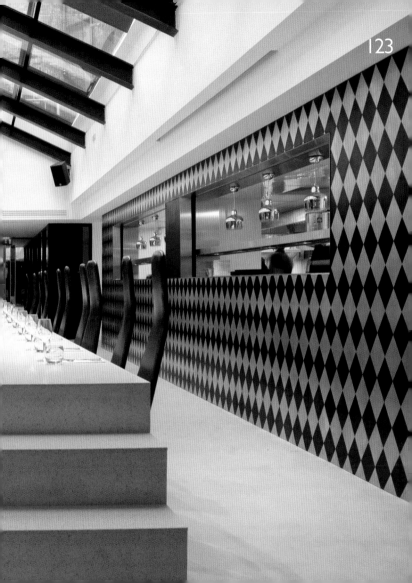

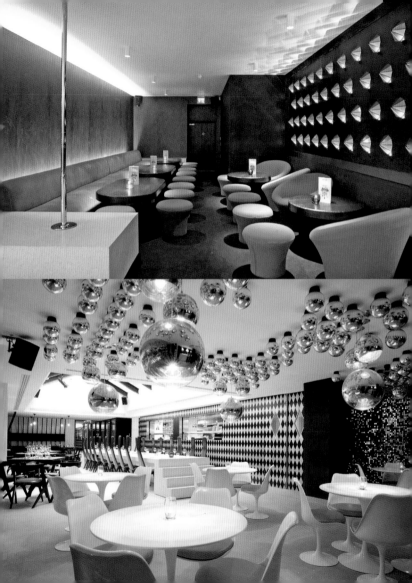

Part cocktail bar, part cabaret restaurant, this lovely little spot designed with surreal aplomb by iconic British designer Tom Dixon, is a welcome retreat from the dire tourist-traps that surround at Covent Garden. The cocktails and food are great, and the entertainment just as impressive—acrobatics while you eat, anyone? If you're feeling inspired, you too can get involved, with tables pushed out of the way post-dinner to facilitate your own high-jinx. The circus was never this fun, or this stylish!

Teils Cocktail-Bar, teils Restaurant mit Kabarett-Show bietet dieser reizende Ort, der mit surrealer Gelassenheit vom einzigartigen britischen Designer Tom Dixon gestaltet wurde, eine willkommene Zuflucht vor den grässlichen Touristenfallen um Covent Garden. Die Cocktails und das Essen sind großartig und die Unterhaltung ebenso beeindruckend. Mag noch jemand etwas Akrobatik zum Essen? Sollten Sie sich inspiriert fühlen, können Sie auch gerne mitmachen. Nach dem Abendessen werden die Tische beiseitegestellt, um Platz für ihre eigenen Unterhaltungskünste zu schaffen. Selbst ein echter Zirkus war niemals so lustig, geschweige denn so stilvoll!

Moitié bar à cocktails, moitié resto-cabaret, ce petit lieu charmant conçu avec un aplomb surréaliste par l'emblématique designer britannique Tom Dixon, est un havre de paix loin des horribles pièges-à-touristes qui entourent Covent Garden. Les cocktails et la nourriture sont excellents, et le divertissement tout aussi impressionnant : voir des acrobaties pendant que vous mangez, ça vous tente ? Si vous vous sentez inspirés, vous pouvez vous aussi y participer. Les tables seront même dégagées après dîner pour faire place à vos propres pirouettes. Le cirque n'a jamais été autant amusant – ou aussi élégant !

Coctelería, cabaret y restaurante a partes iguales, el coqueto local diseñado con surrealista arrojo por el icónico Tom Dixon permite escapar de las innombrables trampas para turistas que rodean Covent Garden. Los combinados y la comida son excelentes, y el espectáculo no desmerece en absoluto: ¿a quién le amargan unos acróbatas durante la cena? Si se siente inspirado, tendrá cumplida ocasión de unirse al espectáculo: las mesas se harán a un lado para que presente su número. El circo nunca fue tan divertido…ni tan elegante.

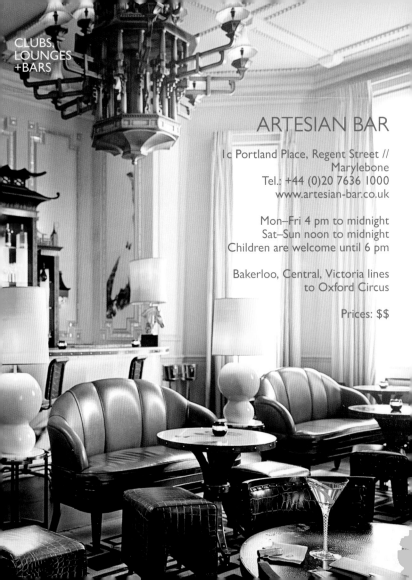

CLUBS, LOUNGES +BARS

ARTESIAN BAR

1c Portland Place, Regent Street //
Marylebone
Tel.: +44 (0)20 7636 1000
www.artesian-bar.co.uk

Mon–Fri 4 pm to midnight
Sat–Sun noon to midnight
Children are welcome until 6 pm

Bakerloo, Central, Victoria lines
to Oxford Circus

Prices: $$

The setting is divine, the food exquisite and the drinks a work of art—no wonder Artesian Bar, located at London's exclusive Langham hotel, is widely considered to be one of the best in London. Designed by David Collins Studio, the central focus of this magnificent fit-out is the ornate wooden Chinese-style altarpiece, home to the bar's extensive selection of spirits—including 50 different varieties of rum. The cocktails are simply breathtaking, and reason enough to visit this delightful spot.

Traumhafte Kulisse, ausgezeichnetes Essen und die Drinks gleichen einem Kunstwerk. Kein Wunder, dass die Artesian Bar in Londons exklusivem Langham Hotel von vielen als eine der Besten Londons bezeichnet wird. Das Design ist dem David Collins Studio zu verdanken. Im Mittelpunkt dieser prachtvollen Ausstattung steht die kunstvoll verzierte Holzaltartafel nach chinesischem Vorbild, in der sich die umfangreiche Auswahl an Spirituosen befindet, darunter auch 50 verschiedene Sorten Rum. Die Cocktails sind schlicht und einfach atemberaubend und Grund genug für einen Besuch an diesem bezaubernden Ort.

L'endroit est divin, la nourriture exquise et la boisson une œuvre d'art. Pas étonnant que l'Artesian Bar, du select Langham Hotel de Londres, soit largement considéré comme l'un des meilleurs de Londres. Conçu par David Collins Studio, le point central de cette mise en scène magnifique est l'autel de style chinois, où s'aligne une vaste sélection de spiritueux, dont une cinquantaine de variétés différentes de rhum. Les cocktails à vous couper le souffle sont une raison suffisante pour visiter ce lieu exquis.

El entorno es maravilloso, la comida exquisita, y las bebidas auténticas obras de arte: a nadie puede sorprender que el Artesian Bar, instalado en el exclusivo hotel Langham, esté considerado uno de los mejores de todo Londres. Diseñado por David Collins Studio, el punto focal de sus magníficos interiores es el retablo central de madera, de estilo chino, que acoge la extensa colección de licores del local, incluidas 50 variedades de ron. Una palabra basta para describir los combinados: asombrosos. Sólo por ellos vale la pena acercarse a este extraordinario local.

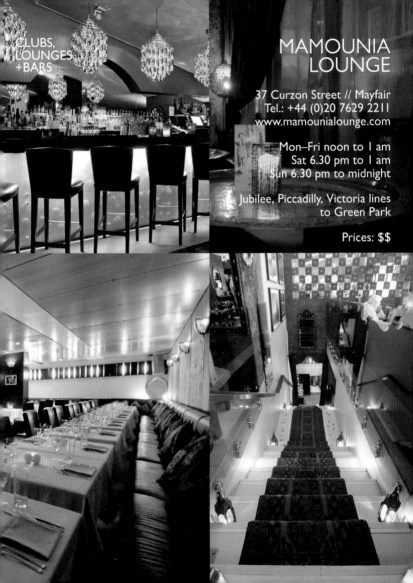

CLUBS, LOUNGES +BARS

MAMOUNIA LOUNGE

37 Curzon Street // Mayfair
Tel.: +44 (0)20 7629 2211
www.mamounialounge.com

Mon–Fri noon to 1 am
Sat 6.30 pm to 1 am
Sun 6.30 pm to midnight

Jubilee, Piccadilly, Victoria lines
to Green Park

Prices: $$

The Middle East isn't really known for its alcoholic beverages—but Mamounia is. This Morocco-inspired bar, which has been decorated to reflect a decadent, exotic Middle Eastern aesthetic, is famed for its delicious cocktails and gorgeous decor. Downstairs there's also a restaurant that specialises in Lebanese, Moroccan and French cuisine, equally as tantalising. Those wishing to smoke a shisha pipe can do so too, with a special area dedicated to this most ancient of traditions. Belly dancing rounds out this unique experience.

Der Nahe Osten ist nicht unbedingt für seine alkoholischen Getränke berühmt – Mamounia allerdings schon. Diese Bar im marokkanischen Stil, deren Dekoration eine dekadente, exotische Ästhetik des Nahen Ostens widerspiegeln soll, ist bekannt für ihre vorzüglichen Cocktails und ihr wunderschönes Dekor. Geht man die Stufen hinab, gelangt man in ein Restaurant, das mit gleichermaßen verlockenden Spezialitäten aus der libanesischen, marokkanischen und französischen Küche aufwartet. Auch Shishas können in einem speziell für diese uralte Tradition hergerichteten Bereich geraucht werden. Abgerundet wird das Ganze durch Bauchtanz-Darbietungen.

Le Moyen-Orient n'est pas vraiment célèbre pour ses boissons alcoolisées, mais ce n'est pas le cas de Mamounia. Ce bar inspiré du Maroc, qui a été décoré pour refléter une esthétique orientale décadente et exotique, est célèbre pour ses délicieux cocktails et son décor magnifique. En bas, un restaurant tout aussi alléchant se spécialise dans les cuisines libanaise, marocaine et française. Pour ceux qui désirent fumer le narguilé, un espace est réservé à la plus ancienne des traditions. Des danses orientales complèteront cette expérience unique.

Oriente Medio no es especialmente conocido por sus bebidas alcohólicas, pero el Mamounia sí lo es. El bar, de inspiración marroquí, ha sido decorado para reflejar una decadente y exótica estética oriental y es conocido tanto por sus magníficos cócteles como por sus espectaculares interiores. En la planta baja cuenta también con un restaurante no menos espectacular, especializado en cocina libanesa, francesa y marroquí. Quienes deseen fumar en narguile podrán hacerlo también en una sala especialmente dedicada a esta antiquísima tradición. Para completar esta experiencia única, como no, hay también danza del vientre.

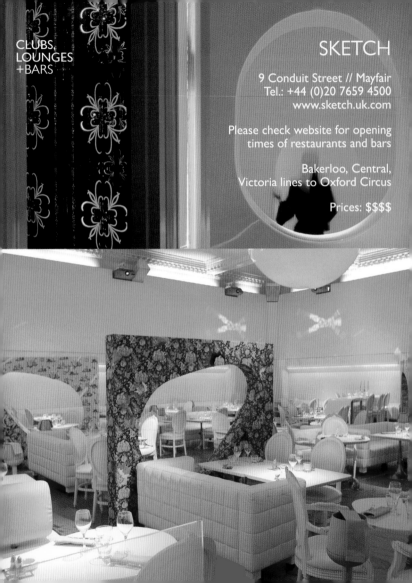

SKETCH

9 Conduit Street // Mayfair
Tel.: +44 (0)20 7659 4500
www.sketch.uk.com

Please check website for opening
times of restaurants and bars

Bakerloo, Central,
Victoria lines to Oxford Circus

Prices: $$$$

Of the artsy persuasion? No trip to London should be complete without a trip to the über-stylish sketch. Housed within the converted 18th century building in Conduit Street, also home to restaurants conceived by French master chef Pierre Gagnaire and restaurateur Mourad Mazouz, it is truly a sight to behold. It's also a wonderful spot to sip cocktails and watch the parade of effortlessly stylish patrons enjoying pre-dinner drinks before their meal at the Lecture Room & Library, sketch's Michelin-starred fine dining restaurant.

Sie mögen es kunstbeflissen? Bei einer Reise nach London darf ein Besuch des überaus stilvollen sketch nicht fehlen. In dem umgebauten Gebäude aus dem 18. Jahrhundert in der Conduit Street, in dem auch vom französischen Meisterkoch Pierre Gagnaire und Restaurantbesitzer Mourad Mazouz konzipierte Restaurants untergebracht sind, bietet diese Bar einen unvergesslichen Anblick. Sie ist außerdem ein hervorragender Ort, um Cocktails zu genießen und die vorbeidefilierenden, mühelos stylishen Stammgäste dabei zu beobachten, wie sie ihren Aperitif vor dem Abendessen im mit Michelin-Sternen ausgezeichneten Gourmetrestaurant des sketch, dem Lecture Room & Library, einnehmen.

Du genre artiste ? Aucun voyage à Londres ne serait complet sans une visite de ce bar über-chic, le sketch. Installé dans un bâtiment du XVIIIe siècle reconverti de Conduit Street, qui abrite également des restaurants tenus par le chef Pierre Gagnaire et le restaurateur Mourad Mazouz, c'est vraiment un spectacle à voir. C'est aussi un endroit merveilleux pour siroter des cocktails et regarder le défilé de clients d'une élégance naturelle qui viennent prendre un verre avant leur dîner au Lecture Room & Library, le restaurant gastronomique du sketch, étoilé au Michelin.

Si tiene inquietudes artísticas, su visita a Londres no habrá sido completa hasta haber pasado por el prodigio de elegancia que es el sketch. Instalado en un reconvertido edificio dieciochesco de Conduit Street que acoge también los restaurantes del gran chef francés Pierre Gagnaire y el restaurador Mourad Mazouz, vale la pena acercarse siquiera para verlo. Es también un magnífico local en el que pedir un cóctel y contemplar el exquisito espectáculo de su elegante clientela disfrutando de una copa antes de sentarse a comer en el Lecture Room & Library, el espléndido restaurante (con estrella Michelín) del sketch.

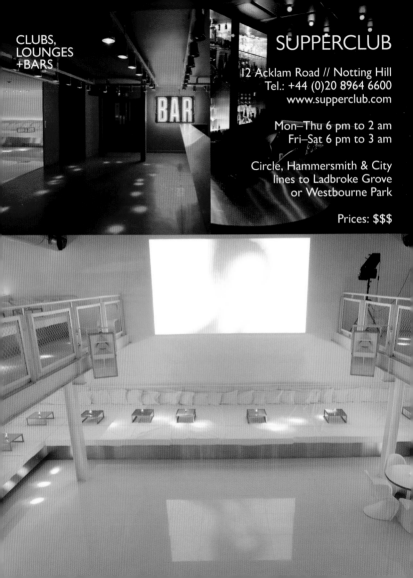

It might not be slap-bang in the centre of town, but that doesn't matter a bit—supperclub is a destination. And quite possibly the destination for those looking for a stylish night out full of surprises. Over two levels, the club, decorated almost entirely in white, features several bars and a central dance floor. Grab a spot upstairs for the best vantage spot. But don't just cast your eyes down—look up and you might just see a dancer suspended from the ceiling. Expect the unexpected.

Zwar befindet sich der supperclub nicht unmittelbar im Herzen der Stadt, das macht aber nichts, denn er ist auf jeden Fall einen Besuch wert. Und sicherlich statten diejenigen, denen der Sinn nach einer stilvollen Nacht voller Überraschungen steht, ihm mehr als nur einen ab. Der fast ausschließlich in Weiß dekorierte Klub erstreckt sich über zwei Ebenen und verfügt über verschiedene Bars und eine zentrale Tanzfläche. Von oben hat man die beste Sicht, aber richten Sie Ihren Blick nicht nur ab-, sondern auch aufwärts, vielleicht bewegt sich dort gerade eine Tänzerin frei von der Decke hängend. Erwarten Sie das Unerwartete!

Ce n'est pas à proprement parler le centre-ville, mais ça n'enlève rien : le supperclub est un must. Et très probablement le must de ceux qui recherchent une nuit raffinée pleine de surprises. Sur plus de deux niveaux, le club, presque entièrement décoré en blanc, propose plusieurs bars et un dancefloor central. Choisissez un spot du haut pour un meilleur point de vue. Mais ne vous focalisez pas sur le bas ! Si vous levez les yeux et vous aurez peut-être la chance d'apercevoir des danseurs suspendus au plafond. Attendez-vous à l'inattendu.

Puede que no se trate del más céntrico de los locales, pero eso poco o nada importa: supperclub es de esos sitios a los que hay que ir. Desde luego, es de visita obligada para quienes valoran la elegancia y quieren pasar una noche llena de sorpresas. El club, decorado casi exclusivamente en blanco, se extiende a lo largo de dos plantas y dispone de varias barras y una pista central de baile. En el piso superior están los mejores asientos. Pero no se limite a mirar hacia abajo: si alza la vista, puede que descubra a un bailarín suspendido del techo. Aquí, lo inusitado es la norma.

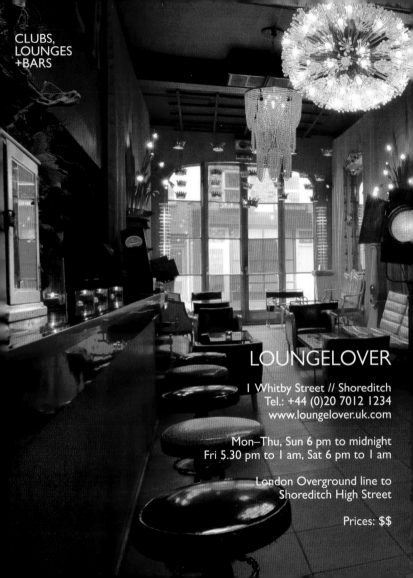

CLUBS,
LOUNGES
+BARS

LOUNGELOVER

1 Whitby Street // Shoreditch
Tel.: +44 (0)20 7012 1234
www.loungelover.uk.com

Mon–Thu, Sun 6 pm to midnight
Fri 5.30 pm to 1 am, Sat 6 pm to 1 am

London Overground line to
Shoreditch High Street

Prices: $$

Tucked away on a side-street in London's trendy Shoreditch, a stone's throw from Brick Lane, Loungelover is an absolute delight to stumble across. Previously a meat packing factory, it's now a lavishly extravagant space in which to sip on some seriously delicious cocktails. Originally opened to cater for the pre-dinner drinks crowd from their nearby restaurant, Les Trois Garçons, and several years on it's still going strong. In the notoriously fickle world of London's hip East End, this says a lot.

Gut versteckt in einer Seitenstraße von Londons trendigem Viertel Shoreditch und nur einen Katzensprung von der Brick Lane entfernt, gehört Loungelover zu den absoluten Highlights, die man sich nicht entgehen lassen sollte. Aus der einstigen Fleischverpackungsfabrik ist heute ein großzügiger extravaganter Ort geworden, an dem man wahrhaft köstliche Cocktails genießen kann. Ursprünglich wurde die Bar gegründet, um den Gästen des nahegelegenen Restaurants Les Trois Garçons Aperitifs anzubieten, und nach mittlerweile einigen Jahren läuft das Geschäft noch immer gut. Im unbeständigen angesagten Londoner East End will das schon was heißen.

Niché dans une rue latérale du quartier tendance de Shoreditch, à un jet de pierre de Brick Lane, Loungelover est l'un de ces plaisirs absolus sur lesquels on est heureux de tomber. Cette ancienne usine de conditionnement de viandes est devenue un espace somptueux et extravagant dont il fait bon siroter les cocktails franchement délicieux. Au départ, Les Trois Garçons ont ouvert cet endroit pour étancher la soif des foules qui venaient diner dans leur restaurant avoisinant. Plusieurs années après, le lieu est toujours aussi vivant. Et pour ce milieu mondain notoirement infidèle qu'est celui de l'East End hype londonien, ça en dit long !

Semiescondido en una calleja del muy en boga barrio londinense de Shoreditch, a tiro de piedra de Brick Lane, Loungelover oculta una sorpresa tras otra. La antigua planta de empaquetado de carne se ha convertido en un suntuoso y extravagante local con una asombrosa selección de cócteles. Inaugurado originariamente para ofrecer una bebida previa a la cena a los comensales del contiguo restaurante Les Trois Garçons, en los años que han pasado desde entonces no ha perdido su atractivo, y eso, en el voluble mundo de la noche del este de London, dice mucho.

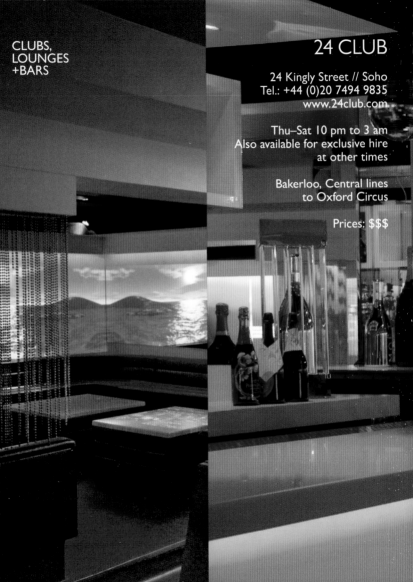

CLUBS,
LOUNGES
+BARS

24 CLUB

24 Kingly Street // Soho
Tel.: +44 (0)20 7494 9835
www.24club.com

Thu–Sat 10 pm to 3 am
Also available for exclusive hire
at other times

Bakerloo, Central lines
to Oxford Circus

Prices: $$$

This state-of-the-art bar boasts a sleek interior with custom-designed LED lighting and interactive panels. Too high-tech to wrap your head around? Consider this: both the lighting and the panels can be customised with any kind of image or lighting combination you can think of. Put your drink down on the bar and it lights up, touch it and it sends out a beam of light, alerting the barman you need serving. This, my friends, is the future—stylish, isn't it?

Diese hochmoderne Bar besticht durch elegante Innenräume mit maßgeschneiderter LED-Beleuchtung und interaktiven Bedienfeldern. Zu viel Hightech für Sie, um das Konzept nachzuvollziehen? Sie müssen sich das so vorstellen: Sowohl die Beleuchtung als auch die Bedienfelder können auf jede Bilder- oder Lichtkombination eingestellt werden, die Sie sich nur denken können. Sie stellen Ihr Getränk an der Bar ab und schon leuchtet sie auf. Sie berühren die Theke und ein Lichtstrahl signalisiert dem Barkeeper, dass Sie ihn rufen. Das, meine Freunde, ist die Zukunft und hat Stil. Nicht wahr?

Ce bar dernier cri s'enorgueillit d'un intérieur élégant avec un éclairage LED de conception exclusive et des panneaux interactifs. Trop de technologie pour votre petite tête ? Considérez ceci : l'éclairage et les panneaux peuvent être personnalisés avec tous les types de combinaison d'images ou d'éclairage imaginables. Posez votre verre sur le bar et il s'allume, touchez-le et ça envoie un faisceau de lumière, qui alerte le barman que vous en voulez un autre. Ça, mes amis, c'est l'avenir ! Classe, non ?

Este modernísimo bar cuenta con un estilizado interior en el que la iluminación de LEDs, diseñada a medida, se combina con paneles interactivos. ¿La jerga tecnológica le supera? Digámoslo de otra manera: tanto la luz como los paneles pueden personalizarse con cualquier imagen o iluminación concebible. Al posar la copa sobre la barra esta se ilumina, y si la tocamos de ella parte un haz de luz que avisa al camarero más cercano. Eso, amigos míos, es el futuro: elegante, ¿no les parece?

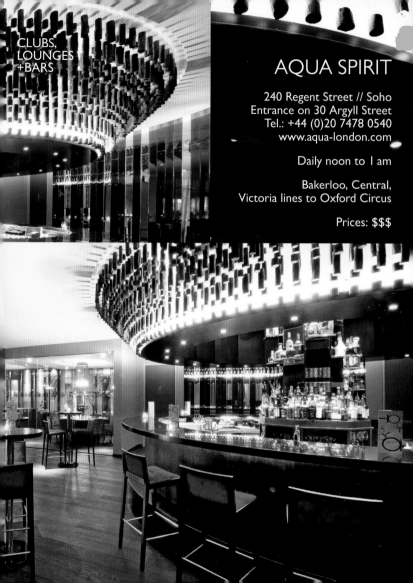

Roof-top bars and restaurants have never really taken off in London—you can blame the Capital's reputation for inclement weather—but aqua spirit is bucking that trend. Atop one of London's most iconic buildings, the former Dickens & Jones department store on Regent Street, it offers gorgeous food and drink, and boasts one of the best views around. And if it does start to rain, don't despair—the interior is just as spectacular, and well worth a visit. A gorgeous spot for a pre-dinner drink.

Bars und Restaurants auf Dachterrassen haben sich in London nie wirklich durchgesetzt, wofür dem Ruf der Hauptstadt für schlechtes Wetter die Schuld gegeben werden kann. aqua spirit widersetzt sich jedoch diesem Trend. Hoch oben auf einem von Londons faszinierendstem Gebäude, dem ehemaligen Kaufhaus Dickens & Jones in der Regent Street, werden fantastisches Essen und Getränke sowie einer der besten Ausblicke in der Umgebung geboten. Und falls Regen aufkommt, ist dies kein Grund zur Sorge, denn die Innenraumgestaltung ist ebenso spektakulär und einen Besuch wert. Ein wunderschöner Ort für einen Aperitif.

Les bars et restaurants sur toits-terrasses n'ont jamais réellement percé à Londres. On peut rejeter la faute sur la capitale anglaise à la météo réputée peu clémente. aqua spirit a décidé d'inverser la tendance. Situé dans la Regent Street, au sommet de l'ancien grand magasin Dickens & Jones, l'un des bâtiments les plus emblématiques de Londres, aqua spirit propose une cuisine et des rafraîchissements délicieux et possède l'un des plus beaux panoramas du coin. Et s'il commence à pleuvoir, ne désespérez pas : l'intérieur est tout aussi spectaculaire et vaut lui aussi le détour. Un lieu magnifique pour prendre un verre avant de dîner.

Los bares y restaurantes de azotea no han sido nunca verdaderamente populares en Londres, seguramente debido a las inclemencias del tiempo en la capital, pero aqua spirit parece estar invirtiendo esa tendencia. Situado sobre uno de los edificios más característicos de Londres, los antiguos grandes almacenes Dickens & Jones de Regent Street, ofrece una excepcional carta de comida y bebida y puede alardear de vistas incomparables. Y si empieza a llover no pasa nada: el interior es igual de espectacular y bien merece una visita. El lugar ideal para echar una copa antes de la cena.

HIGHLIGHTS

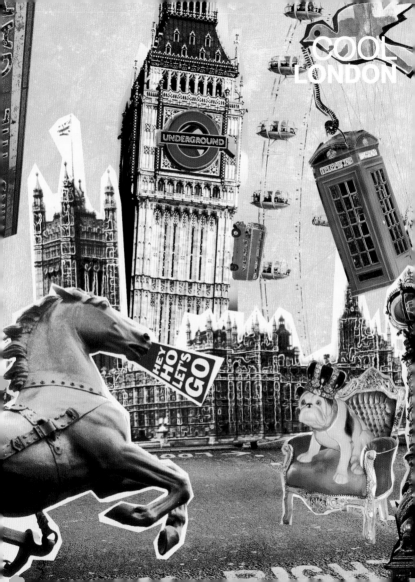

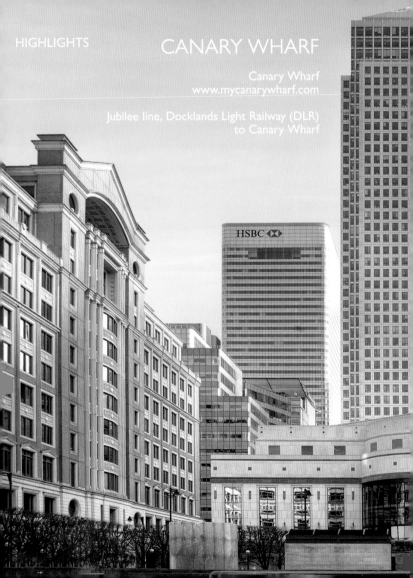

CANARY WHARF

Canary Wharf
www.mycanarywharf.com

Jubilee line, Docklands Light Railway (DLR)
to Canary Wharf

Canary Wharf, the home of London's financial district, is the undisputed stomping ground of men in suits, spotted most days striding between office and power lunch, talking loudly on their phones. But plug your ears and look upwards—far more interesting than their overheard conversations is the array of seriously impressive, thoroughly modern architecture that house these be-suited businessmen. Towering skyscrapers give this corner of London a modern makeover and should be a must-see spot for any architecture buff.

In Canary Wharf ist Londons Finanzdistrikt zu Hause. Hier befindet sich das unangefochtene Revier von Männern im Anzug, die meist tagein, tagaus zwischen Büro und Geschäftsessen hin und her eilen und dabei lautstark Gespräche am Handy führen. Aber halten Sie sich einen Moment die Ohren zu und sehen Sie nach oben, denn weitaus interessanter als das Belauschen der Gespräche ist die wahrhaft beeindruckende und absolut moderne Architektur der Häuser, die diese Schlipsträger beherbergen. Emporragende Wolkenkratzer verleihen dieser Londoner Gegend einen zeitgemäßen Look. Kein Architektur-Fan sollte sich das entgehen lassen.

Canary Wharf, le quartier de la finance de Londres, est l'habitat de prédilection incontesté des hommes en costumes, que l'on peut voir la plupart du temps faire la navette entre le bureau et les déjeuners d'affaires, parlant très fort dans leurs téléphones portables. Mais bouchez-vous les oreilles et regardez vers le haut : beaucoup plus intéressant est le décor de cette architecture résolument moderne, absolument impressionnante, où logent ces cols blancs ennuyeux. Les gratte-ciel élancés ont modernisé ce coin de Londres et devraient être au programme de tout mordu d'architecture.

Canary Wharf, centro neurálgico del distrito financiero de Londres, es el territorio por el que campan a sus anchas hombres trajeados en tránsito continuo entre sus oficinas y una comida de negocios, hablando a gritos por sus teléfonos móviles. Pero si nos tapamos los oídos y alzamos la vista, descubriremos algo mucho más interesante que las conversaciones entreoídas de los ejecutivos: un amplio muestrario de impresionante arquitectura moderna. Los rascacielos han servido para modernizar este rincón de Londres, y son de visita obligada para quienes se interesan por la arquitectura.

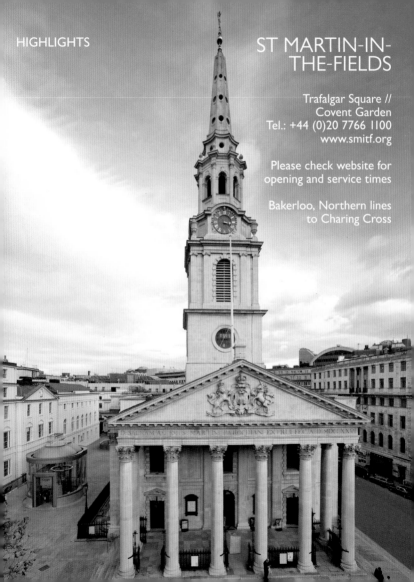

ST MARTIN-IN-THE-FIELDS

Trafalgar Square //
Covent Garden
Tel.: +44 (0)20 7766 1100
www.smitf.org

Please check website for
opening and service times

Bakerloo, Northern lines
to Charing Cross

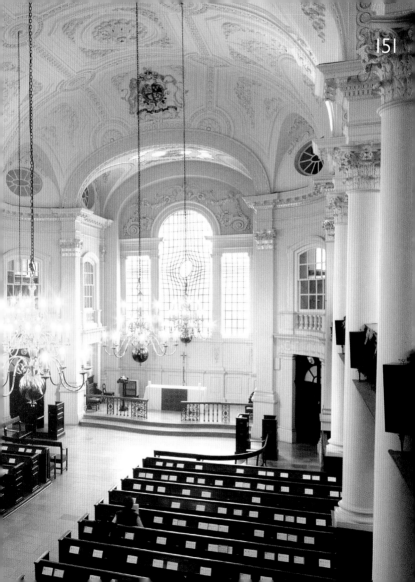

Popping over to Trafalgar Square to see those famous lions? Take a detour to the north-east corner for a look at this beautiful old Anglican church. A church was on this site from 1222 and rebuilt in 1542, back then it was, quite literally, in the fields between the cities of Westminster and London. The current church dates back to 1726 and is now right in the middle of the action, and as well as regular services it is famed for lunchtime and evening concerts and regular jazz nights at the Café in the Crypt.

Sind Sie gerade auf dem Weg zum Trafalgar Square, um sich die berühmten Löwen anzusehen? Dann machen Sie doch einen Abstecher zum nordöstlichen Ende des Platzes, um einen Blick auf diese wunderschöne alte anglikanische Kirche zu werfen. Seit dem Jahr 1222 existiert an diesem Ort eine Kirche, die 1542 umgebaut wurde. Damals stand sie im wahrsten Sinne des Wortes in den Feldern zwischen den Städten Westminster und London. Die Kirche, wie wir sie heute kennen, stammt aus dem Jahr 1726 und steht heute im Mittelpunkt des Geschehens. Hier finden nicht nur regelmäßige Gottesdienste statt, sondern die Kirche ist auch bekannt für ihre Konzerte am Mittag und Abend sowie für regelmäßig stattfindende Jazz-Nächte im Café in the Crypt.

Vous allez faire un tour à Trafalgar Square pour voir les célèbres lions ? Faites un détour par le coin nord-est pour jeter un œil à cette ancienne et superbe église anglicane. Depuis 1222, une église se tenait sur ce site. Reconstruite en 1542, elle se trouvait, à l'époque, littéralement « in the fields », c'est-à-dire « dans les champs », entre les villes de Westminster et de Londres. L'église actuelle, qui date de 1726, se trouve maintenant au cœur de l'action, et en plus de ses services anglicans réguliers, elle est réputée pour les concerts qui s'y tiennent à midi et le soir, ainsi que les soirées de jazz régulières au Café in the Crypt.

¿Tenías planeado acercarte a Trafalgar Square para ver los famosos leones? Vale la pena dar un rodeo por la esquina nordeste para contemplar esta hermosa iglesia anglicana. La iglesia que ocupa este solar desde 1222 (reconstruida en 1542) se alzaba literalmente entre los campos que se extendían entre las ciudades de Londres y Westminster. La iglesia actual data de 1726 y se encuentra en pleno meollo urbano. En ella se celebran no sólo misas, sino también conciertos matinales y vespertinos y veladas de jazz en el Café in the Crypt.

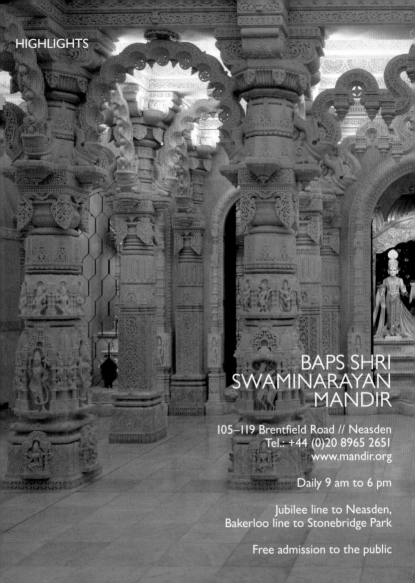

BAPS SHRI SWAMINARAYAN MANDIR

105–119 Brentfield Road // Neasden
Tel.: +44 (0)20 8965 2651
www.mandir.org

Daily 9 am to 6 pm

Jubilee line to Neasden,
Bakerloo line to Stonebridge Park

Free admission to the public

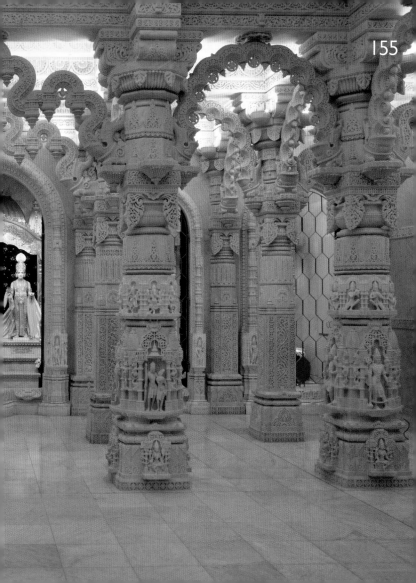

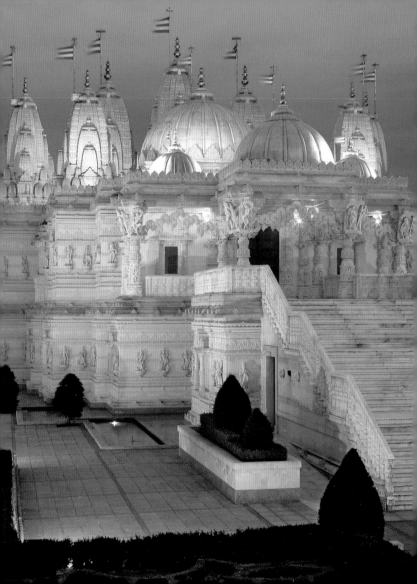

It has been described as the eighth wonder of the world—and no wonder! Rising from the chimney-potted suburban surroundings like a shimmering white mirage, this breathtaking structure, commonly referred to as the Neasden Temple, is the first traditional Hindu "mandir", or temple, constructed in Europe. And it is impressive indeed. Completed in 1995, it's made from 2,820 tonnes of Bulgarian limestone and 2,000 tonnes of Italian Carrara, hand-carved in India and painstakingly reassembled, slap-bang in the middle of North West London.

Er wird als das achte Weltwunder bezeichnet und das ist wiederum kein Wunder! Wie eine schimmernde weiße Luftspiegelung erhebt sich dieser atemberaubende Bau aus der vorstädtischen Schornstein-landschaft. Allgemein als der Neasden-Tempel bezeichnet handelt es sich um den ersten traditionellen hinduistischen „mandir" oder Tempel, der in Europa erbaut wurde. Das überaus beeindruckende Gebäude wurde 1995 abgeschlossen und ist aus 2 820 Tonnen bulga-rischen Kalksteins und 2 000 Tonnen italienischen Carrara-Marmors gefertigt. Die Teile wurden in Indien einzeln von Hand gemeißelt und sorgfältig mitten im Nordwesten Londons wieder zusammengefügt.

On l'a décrite comme la huitième merveille du monde et ça n'a rien d'étonnant ! Se dressant au dessus des cheminées de son voisinage banlieusard comme un mirage blanc scintillant, cette construction à vous couper le souffle, communément appelé le Temple Neasden, est le premier « mandir » hindou traditionnel construit en Europe. Et en effet, c'est impressionnant. Achevé en 1995, il fut construit à partir de 2 820 tonnes de calcaire bulgare et 2 000 tonnes de marbre de Carrare italien, sculpté à la main en Inde et soigneuse-ment remonté, en plein milieu du Nord-ouest londonien.

Ha sido descrito (y no sin razón) como la octava maravilla del mun-do. Entre las hileras de chimeneas suburbanas de su entorno se alza como un resplandeciente espejismo esta estructura asombrosa, comúnmente conocida como el Templo de Neasden. Se trata del primer "mandir" (templo) hindú construido en Europa. Impresio-nante lo es, desde luego. Completado en 1995, para su erección fueron precisas 2 820 toneladas de caliza búlgara y 2 000 toneladas de mármol de Carrara, talladas a mano en India y cuidadosamente reensambladas en pleno centro del noroeste londinense.

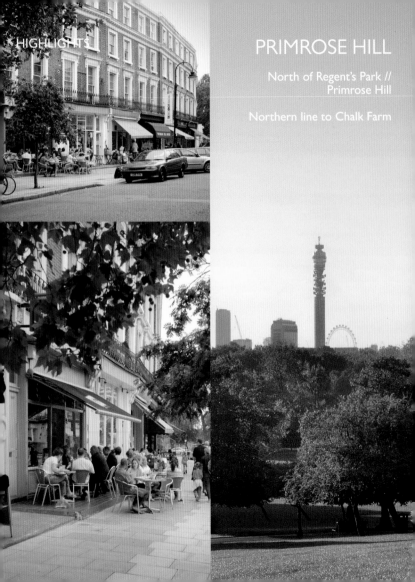

PRIMROSE HILL

North of Regent's Park //
Primrose Hill

Northern line to Chalk Farm

As well as being THE place for celeb-spotting—Jamie Oliver, Jude Law and Gwen Stefani all live here—Primrose Hill is also home to one of London's best-loved and most popular parks. Perched atop the hill, situated on the north side of Regent's Park, picnickers have sweeping views of London—and a prime spot for some great people-watching. If that gets boring, there are always the surrounding pubs, where you can prop up the bar next to a seriously big star.

Primrose Hill ist nicht nur DER Ort, um einen Blick auf die hier lebenden berühmten Persönlichkeiten wie Jamie Oliver, Jude Law und Gwen Stefani zu erhaschen, sondern bietet auch einen der beliebtesten Parks Londons. Vom Hügel auf der Nordseite des Regent's Parks haben Picknicker einen weitreichenden Blick auf London. Außerdem ist der Ort bestens zum Leutebeobachten geeignet. Sollte dabei Langeweile aufkommen, laden die umliegenden Pubs ein, in denen Sie neben großen Stars an der Theke lehnen können.

RANKIN'S SPECIAL TIP

We walk our dogs on Primrose Hill—it's the only place that tires them out.

En plus d'être « LE » lieu de prédilection pour apercevoir des célébrités (Jamie Oliver, Jude Law et Gwen Stefani y ont tous une résidence), Primrose Hill abrite aussi l'un des parcs les plus aimés et les plus populaires de Londres. Perchés au sommet de la butte, situés sur le côté nord de Regent's Park, les amateurs de pique-niques profitent d'une vue imprenable sur la capitale, et d'un site de premier ordre pour apercevoir des personnalités célèbres ! Lorsque vous serez lassé, vous pourrez vous rendre dans les pubs du coin et jouer des coudes au bar avec quelque grosse pointure du showbiz.

Más allá de ser el mejor lugar para ver a los famosos en su salsa (Jamie Oliver, Jude Law y Gwen Stefani viven aquí), en Primrose Hill se encuentra uno de los parques más queridos y populares de Londres. Sobre lo alto de la colina, en la franja norte de Regent's Park, es posible organizar un picnic con amplísimas vistas de la ciudad y disfrutar de un envidiable emplazamiento desde el que ver a la gente pasar. Si la animación decae, siempre puede acudirse a alguno de los pubs cercanos, donde es fácil encontrar a grandes estrellas acodadas en la barra.

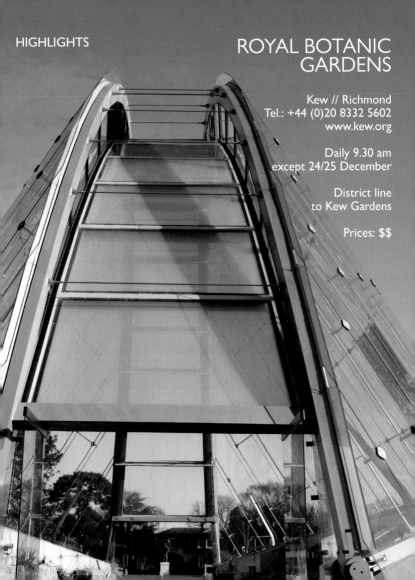

ROYAL BOTANIC GARDENS

Kew // Richmond
Tel.: +44 (0)20 8332 5602
www.kew.org

Daily 9.30 am
except 24/25 December

District line
to Kew Gardens

Prices: $$

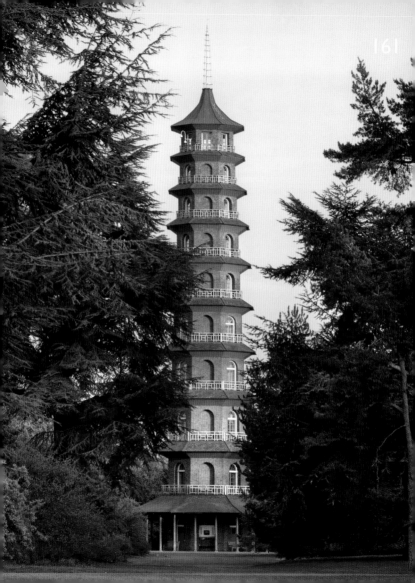

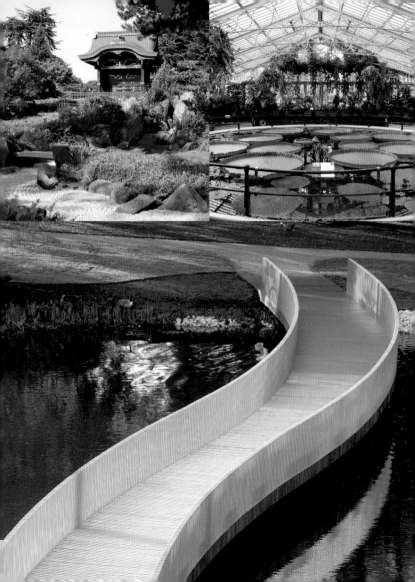

There's just something so beautifully English about strolling through the delightful, historic Kew Gardens—home to one of the world's largest collection of living plants. One feels like one should be putting on one's best Sunday bonnet! Created in 1759, the gardens recently celebrated their 250th anniversary. But a walk around the 300 acres and you feel as though you're still in that bygone era—especially when stepping inside the magical Palm House, built between 1844 and 1848. A sunny day must-do.

Durch die herrlichen historischen Kew Gardens zu spazieren, ist einfach wunderbar englisch. Hier befindet sich eine der weltweit größten Sammlungen lebender Pflanzen. Man hat das Gefühl, man sollte seinen besten Sonntags-Hut tragen. Die Gärten wurden im Jahr 1759 angelegt und feierten erst kürzlich ihr 250. Jubiläum. Schlendert man jedoch durch die 120 ha große Anlage, kommt es einem beinahe so vor, als befände man sich noch immer in längst vergangenen Zeiten, insbesondere beim Betreten des magischen Palmen-Hauses, das zwischen 1844 und 1848 errichtet wurde. An sonnigen Tagen gibt es einfach keinen schöneren Ort.

Il y a quelque chose d'infiniment anglais à se promener à travers les jardins historiques et charmants de Kew Gardens : ils abritent l'une des plus grandes collections de plantes vivantes au monde. On sent que l'on devrait mettre son couvre chef dominical ! Créés en 1759, les jardins ont célébré récemment leur 250e anniversaire. Mais une promenade à travers ces 120 ha vous enverra tout droit dans cette époque révolue, surtout lorsque vous entrerez à l'intérieur de la grande serre, construite entre 1844 et 1848. À visiter absolument lors d'une journée ensoleillée.

Un paseo por el delicioso e histórico Kew Gardens, que acoge una de las mayores colecciones de plantas vivas de todo el mundo tiene siempre algo intrínsecamente inglés. ¡Al visitante puede asaltarle el impulso de ponerse la casaca de los domingos! Creados en 1759, los jardines celebraron recientemente su 250 aniversario, pero un paseo por sus 120 ha bastará para sentirse transportado a épocas pretéritas, especialmente en el interior de la encantadora Palm House, construida entre 1844 y 1848. De visita obligada en un día soleado.

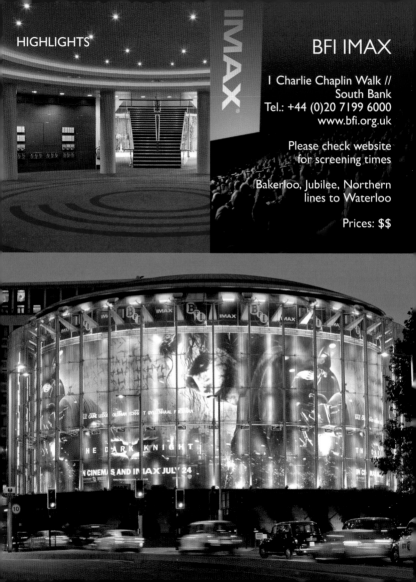

HIGHLIGHTS

BFI IMAX

1 Charlie Chaplin Walk //
South Bank
Tel.: +44 (0)20 7199 6000
www.bfi.org.uk

Please check website
for screening times

Bakerloo, Jubilee, Northern
lines to Waterloo

Prices: $$

Grab a sick-bag and strap yourself in—you're in for one hell of a ride at BFI IMAX. Britain's largest cinema screen is more than 65 ft. high and 85 ft. wide. And if that's too lofty for your brain to take in, consider this—that's nearly five double-decker buses stacked on top of each other! We're feeling sick just thinking about it. But if gargantuan screens aren't your thing, the building, designed by award-winning architect Bryan Avery, is every bit as impressive.

Greifen Sie sich eine Spucktüte und schnallen Sie sich an: Ihnen steht ein Riesenspaß im BFI IMAX bevor! Großbritanniens größte Kinoleinwand ist mehr als 20 m hoch und 26 m breit. Falls Ihnen diese Zahlen wenig sagen, dann stellen Sie sich fünf Doppeldeckerbusse übereinandergestapelt vor! Allein beim Gedanken daran dreht es einem den Magen um. Selbst wenn gigantische Leinwände nicht Ihrem Geschmack entsprechen, ist das vom preisgekrönten Architekten Bryan Avery entworfene Gebäude mindestens ebenso beeindruckend.

Prenez un sac à vomi et attachez votre ceinture : c'est parti pour une virée d'enfer au BFI IMAX. Le plus grand écran de Grande-Bretagne mesure plus de 20 m de haut et 26 m de large. Et si c'est trop d'espace pour votre cerveau, considérez ceci : ça représente près de cinq bus londoniens empilés ! Ca donne le tournis rien que d'y penser. Mais si les écrans gigantesques ne sont pas votre truc, le bâtiment, imaginé par l'architecte primé Bryan Avery, est tout aussi impressionnant.

Hazte con una bolsa para el mareo y agárrate fuerte: en el BFI IMAX te espera la experiencia de tu vida. El cine con la mayor pantalla del Reino Unido mide más de 20 m de alto y 26 de ancho. Y si esas magnitudes escapan a tu comprensión, imagínatelo de la siguiente manera: equivale casi a cinco autobuses de dos pisos puestos uno encima de otro. Se nos va la cabeza sólo de pensar en ello. Pero si las pantallas descomunales no son lo tuyo, el edificio diseñado por el galardonado arquitecto Bryan Avery es igual de impresionante.

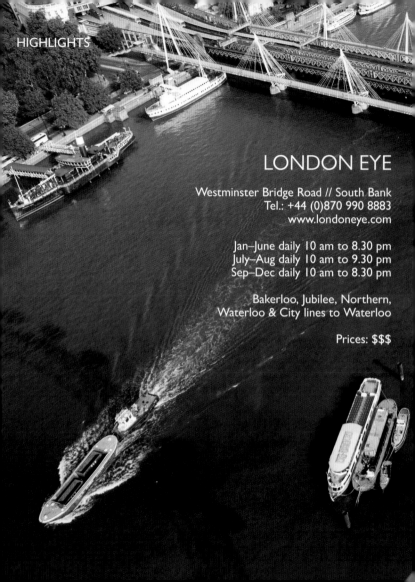

LONDON EYE

Westminster Bridge Road // South Bank
Tel.: +44 (0)870 990 8883
www.londoneye.com

Jan–June daily 10 am to 8.30 pm
July–Aug daily 10 am to 9.30 pm
Sep–Dec daily 10 am to 8.30 pm

Bakerloo, Jubilee, Northern,
Waterloo & City lines to Waterloo

Prices: $$$

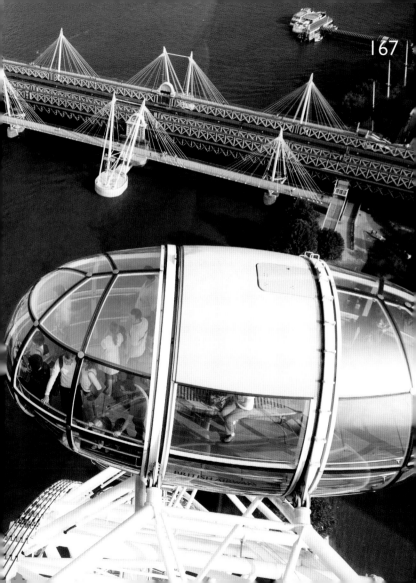

Originally opened as a temporary tourist attraction, the London Eye has staying power—ten years on and millions of tourists later, this slow-moving Ferris wheel has become as much a part of the skyline as that big clock and those red buses. And it's here to stay. Visited by over 3.5 million visitors a year, the wheel, with its futuristic, egg-shaped, air-conditioned carriages, has become the most popular paid tourist attraction in the United Kingdom. We think it's worth the queue.

Ursprünglich als zeitweilige Touristenattraktion eröffnet, zeigt das London Eye echtes Standvermögen. Zehn Jahre und Millionen von Touristen später ist dieses gemütlich drehende Riesenrad mittlerweile ebenso Bestandteil der Skyline wie diese riesige Uhr und die roten Busse. Und es wird auch weiterhin erhalten bleiben. Mit mehr als 3,5 Millionen Besuchern pro Jahr ist das Riesenrad mit seinen futuristischen, eiförmigen, klimatisierten Kabinen die beliebteste zahlungspflichtige Touristenattraktion im Vereinigten Königreich geworden. Wir sind der Meinung, es ist das Schlangestehen wert.

Ouvert à l'origine comme une attraction touristique temporaire, le London Eye a de l'endurance : après une dizaine d'années qui a vu défiler des millions de touristes, le mouvement lent de cette grande roue fait maintenant autant partie des meubles londoniens que la grosse horloge et les bus rouges. Et elle n'est pas près de partir. Visitée par plus de 3,5 millions de visiteurs par an, la grande roue et ses cabines climatisées en forme d'œuf est devenue l'attraction touristique payante la plus populaire du Royaume-Uni. Faites la queue, ça en vaut la peine !

Inaugurado en su día como una atracción turística temporal, el London Eye ha sabido perpetuarse en el tiempo: diez años y millones de turistas después, la parsimoniosa noria es un elemento tan característico del panorama urbano como el reloj ese tan grande y esos autobuses rojos. Y no parece que vaya a desaparecer. Visitada cada año por tres millones y medio de personas, la noria y sus futuristas góndolas aovadas y dotadas de aire acondicionado son la atracción turística de pago más popular del Reino Unido. En nuestra opinión, la cola de espera merece la pena.

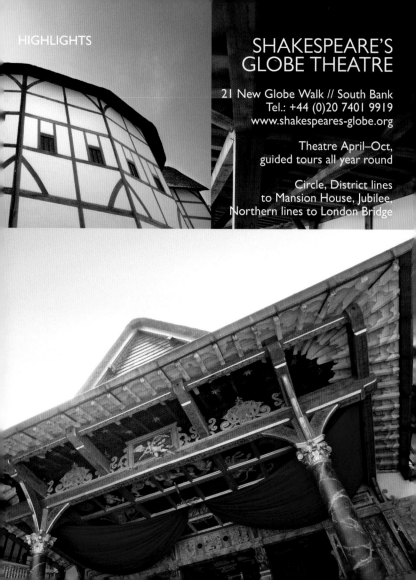

SHAKESPEARE'S GLOBE THEATRE

21 New Globe Walk // South Bank
Tel.: +44 (0)20 7401 9919
www.shakespeares-globe.org

Theatre April–Oct,
guided tours all year round

Circle, District lines
to Mansion House, Jubilee,
Northern lines to London Bridge

The Globe Theatre, opened in 1997, is a faithful reconstruction of the Elizabethan playhouse of the same name that stood by the banks of the Thames in Shakespeare's day. Back then, many of the Bard's most famous works were performed there— and they continue to be today during the theatre's summer season. Performances are just as they would have been—the audiences stand up, there are no stage lights and no mics, and there's plenty of interaction with the crowd. Just don't pack your rotten tomatoes!

Das Globe Theatre wurde 1997 eröffnet und ist eine originalgetreue Rekonstruktion des elisabethanischen Schauspielhauses, dessen Name beibehalten wurde und das zu Shakespeares Zeiten am Ufer der Themse stand. Damals wurden viele der berühmtesten Werke des Dichters in diesem Theater aufgeführt und noch heute kann man hier seine Stücke in der Sommer-Spielzeit des Theaters miterleben. Die Aufführungen finden noch genauso wie zu damaliger Zeit statt: Das Publikum steht, es gibt keinerlei Bühnenbeleuchtung und keine Mikrofone, aber dafür jede Menge Interaktion mit der Menge. Lassen Sie Ihre faulen Tomaten jedoch lieber zu Hause!

RANKIN'S SPECIAL TIP

Watching a play at the Globe feels like a truly British experience—great in the summer.

Ouvert en 1997, le théâtre du Globe est une reconstitution fidèle du théâtre élisabéthain du même nom qui se tenait sur les rives de la Tamise à l'époque de Shakespeare. À l'époque, nombre des pièces les plus célèbres du « Bard », comme on le nomme en Angleterre, étaient jouées ici ; et elles le sont encore aujourd'hui, pendant la saison théâtrale estivale. Les pièces sont jouées tout comme elles l'auraient été : le public est debout, la scène ne comporte ni éclairage ni micro, et il y a beaucoup d'interaction avec les spectateurs. N'y apportez tout de même pas vos tomates pourries !

El Globe Theatre, inaugurado en 1997, es una fiel reconstrucción del recinto teatral isabelino que se alzaba a orillas del Támesis en tiempos de Shakespeare. Muchas de las más famosas piezas del bardo de Avon se escenificaron en él en vida del autor y siguen representándose hoy durante la temporada estival del teatro, tal y como era habitual en aquella época: con el público de pie, sin focos ni micrófonos y mucha interacción con el público. Eso sí: ¡nada de tirar tomates a los actores!

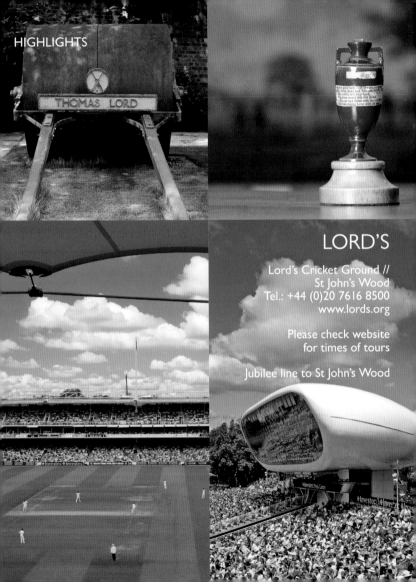

HIGHLIGHTS

LORD'S

Lord's Cricket Ground //
St John's Wood
Tel.: +44 (0)20 7616 8500
www.lords.org

Please check website
for times of tours

Jubilee line to St John's Wood

THOMAS LORD

Anyone for cricket? And what better place to catch a game than in the sport's official birthplace. These hallowed grounds have played host to some of the most important matches in history, and games continue to be held throughout the cricket season. For architecture buffs there's the historic 19th century Pavilion and ultra-modern Media Centre, casting its modern shadow across the field. Sports nuts will likely be more interested in the museum, home to the tiniest, most fiercely sought-after trophy in history—The Ashes.

Lust auf Cricket? Und welcher Ort ist dafür besser geeignet als der offizielle Geburtsort dieser Sportart. Auf diesem heiligen Boden fanden einige der wichtigsten Spiele der Geschichte statt, und während der Cricket-Saison werden auch weiterhin Spiele ausgetragen. Architekturfans können sich hier am historischen Pavillon aus dem 19. Jahrhundert erfreuen. Außerdem gibt es das hochmoderne Media Centre zu bewundern, das seinen innovativen Schatten auf das Spielfeld wirft. Sportfreaks werden sich eher für das Museum begeistern, in dem die kleinste und gleichzeitig begehrteste Trophäe aller Zeiten zu finden ist – The Ashes.

Le cricket vous tente ? Quel meilleur endroit pour aller voir une partie que le lieu de naissance officiel de ce sport. Ces terres sacrées ont reçu quelques-uns des matches les plus importants de l'histoire, et des parties continuent d'y avoir lieu tout au long de la saison sportive. Les amateurs d'architecture apprécieront le pavillon historique du XIXe siècle et la médiathèque dernier cri qui projette son ombre ultramoderne sur la pelouse. Les fous de sports seront probablement plus intéressés par le musée, qui abrite le plus petit trophée de l'histoire, mais aussi le plus férocement convoité : « The Ashes ».

¿Nos vamos a ver un partido de cricket? En ese caso, ¿qué mejor que acudir al lugar en el que oficialmente nació este deporte? Los reverenciados campos de deporte han sido testigos de algunos de los partidos más importantes de la historia y aún hoy acogen encuentros durante la temporada de cricket. Los aficionados a la arquitectura podrán admirar el histórico pabellón decimonónico y el ultramoderno Media Centre, cuya moderna sobra se abate sobre el terreno de juego. Los fanáticos del deporte se sentirán sin duda más atraídos por el museo, en el que se expone el trofeo más diminuto y disputado de la historia: "The Ashes".

BERMONDSEY/SOUTH BANK/SOUTHWARK

Since the 1990s, the southern bank of the Thames, once a forgotten backwater, has been transformed into a vibrant cultural mile where one can enjoy world class art, design, theatre and music. The Silver Jubilee Walkway and the Thames Path link the city's new architectural icons such as the London Eye, Tate Modern, the Globe Theatre or City Hall.

BELGRAVIA/CHELSEA/KNIGHTSBRIDGE/MAYFAIR

The elegant mansions in Belgravia are the most coveted addresses in town. Knightsbridge and Chelsea are famous for their luxury designer shops and department stores. In Mayfair you'll find exclusive gentlemen clubs, auction houses, gourmet restaurants and upscale hotels. All four areas have one thing in common—wealth.

CAMDEN/ISLINGTON

Originally a neighbourhood of poor Irish and Greek immigrants, Camden today is known for its vintage markets, music scene and vibrant night life. Those who prefer it quieter, can stroll along Regent's Canal or take a walk in Regent's Park. In neighbouring Islington one can spot luxury homes, trendy restaurants, cafes and contemporary art galleries.

CITY OF LONDON

Landmarks such as the Tower of London and St Paul's Cathedral are located in The City, the historical core around which the modern metropolis grew. With more than 32,000 people employed here, it is England's commercial and financial centre. Since the 1980s ultramodern offices blocks have dramatically altered the City's skyline. New projects such as the 63-storey Bishopsgate Tower are currently under construction.

COVENT GARDEN/SOHO/WEST END

Even though the area around Covent Garden has undergone major renovations, it retained its historic charm. Originally a collection of expensive town houses, fashionable shops and places of entertainment, it is today a major tourist destination due to its fantastic range of theatres, restaurants and shops. Soho with its pubs, clubs and bars is famous for its vibrant nightlife.

HOXTON/SHOREDITCH/SPITALFIELDS/WHITECHAPEL

The gentrified, long-neglected neighbourhoods of London's East offer trendy art galleries and designer shops. The vibrant area is home to many artists who took over abandoned warehouses in the early 1990s. When new media companies and financial workers joined in, numerous restaurants, bars and clubs sprung up and the property prices instantly rose.

COOL
MAP

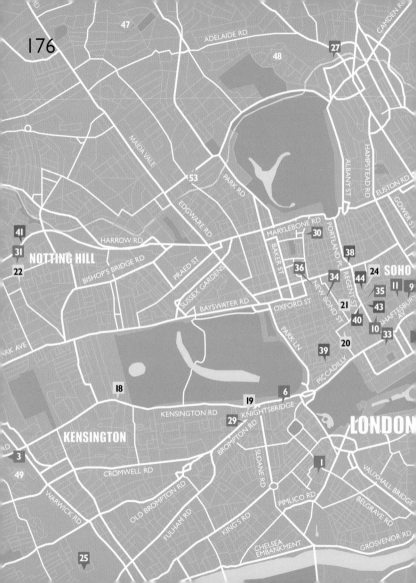

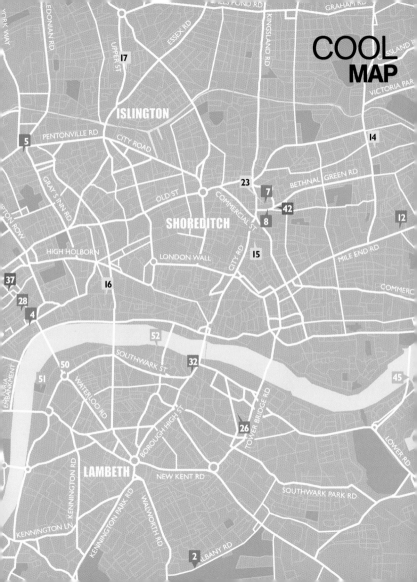

EMERGENCY

Ambulance/Fire/Police Tel.: 999

ARRIVAL

BY PLANE

There are five international airports within a radius of 50 km / 31 miles around London.

CITY AIRPORT (LCY)

www.londoncityairport.com

City Airport 10 km / 6 miles east of the city. With Docklands Light Railway (DLR) to Bank station or to Canning Town station and from there with the Jubilee line to Westminster station. With the DLR to Canary Wharf station and from there with the Jubilee line to Westminster station.

GATWICK (LGW)

www.gatwickairport.com

Gatwick Airport 42 km / 26 miles south of London. With Gatwick Express train departing every 15 mins to Victoria station, travelling time approx. 30–35 mins, or with Southern Trains, travelling time 35 mins. Also every 15 mins with First Capital Connect to London Bridge and King's Cross station, travelling time 30–45 mins. Cheapest option is by coach with National Express Coaches, every 60 mins.

HEATHROW (LHR)

www.heathrowairport.com

Heathrow Airport 22 km / 14 miles west of the city centre, frequented by scheduled flights. With the Heathrow Express train to Paddington station every 15 mins, travelling time 15 mins. Cheaper option is by tube, every 5 mins.

LUTON (LTN)

www.london-luton.co.uk

Luton Airport 53 km / 33 miles northwest of London. From the airport, free shuttle buses to Luton Airport Parkway train station, from there trains to King's Cross station. Every 20 mins buses from easyBus, GreenLine or NationalExpress into London.

STANSTED (STN)

www.stanstedairport.com

Stansted airport 49 km / 30 miles northwest of London, is mainly frequented by low-budget airlines. Every 15 mins with Stansted Express train to London Liverpool Street station. Several times an hour, with buses from National Express Coaches,

COOL
CITY INFO

Terravision Express Shuttle and Terravision Airport Shuttle to London.

BY TRAIN
There is a direct train connection through the Canal from Paris Gare du Nord, Brussels Midi/Zuid or Lille Europe to London St Pancras International with direct access to the tube. Info: Tel.: +44 (0)8432 186 186, www.eurostar.com or www.raileurope.co.uk.

TOURIST INFORMATION

Visit Britain
Thames Tower
Blacks Road
London W6 9EL
Tel.: +44 (0)20 88 46 90 00
www.visitbritain.com

Visit London
Britain & London Visitor Centre (BLVC)
1 Lower Regent Street
BLVCEnquiry@visitlondon.com
Mon–Fri 9 am to 6.30 pm, Sat/Sun 10 am to 4 pm (Sep to 5 pm). The BLVC is run by the official British Tourism Organisation Visit Britain. You will receive free information and advice, and also services such as tickets sales,

currency exchange and souvenirs. Further Tourist Information Centres (TIC) are located in airports and at some train stations, such as:

King's Cross St Pancras, Mon–Sat 7.15 am to 9.15 pm, Sun and Bank Holidays 8.15 am to 8.15 pm
Heathrow, Terminals 1, 2, 3, daily 7.15 am to 9 pm

www.visitlondon.com
Website of London's tourist information with events calendar and an online ticket shop
www.london.gov.uk – The Mayor's website and information on London
www.londontown.com
Tourist information with lots of services such as events calendar, hotel booking

ACCOMMODATION

www.londonbb.com
Bed & Breakfast offers in London
www.perfectplaces.co.uk
Apartments, also for long-term assignments
www.visitlondonoffers.com
Reservation service of the London Tourist Information

www.laterooms.com
Deals at low prices from B&Bs to castles to hotels to apartments to chalets

TICKETS

Ticketmaster
Tel.: +44 (0)870 608 2000
Tel.: +44 (0)161 385 3211
(when calling from outside the UK)
www.ticketmaster.co.uk
Ticket Centre:
Greenwich Tourist Information,
2 Cutty Sark Gardens, Greenwich
Mon–Sat 10 am to 5 pm

tkts – Half Price Ticket Booth
Leicester Square
Mon–Sat 10 am to 7 pm, Sun 11 am to 4 pm
tkts, Brent Cross
Mon–Fri 10 am to 1.30 pm, 2 pm to 4.30 pm,
Sat 10 am to 7 pm, Sun noon to 1.30 pm,
2 pm to 4.30 pm
Last minute sales, discount theater tickets for performances the same day, most tickets are sold at half price.
Info: www.tkts.co.uk

Discounts
London Pass
Free admission without waiting time to more than 55 sights as well as discount on city tours and events, in restaurants and recreational facilities etc. It can be combined with a Travel Card for free bus and train journeys. The pass can be purchased online at www.londonpass.com or at the Britain & London Visitor Centre. One day £ 43 and/or £ 51 incl. Travel Card, two days £ 58 and/or £ 74, three days £ 71 and/or £ 94, six days £ 94 and/or £ 144.

GETTING AROUND

PUBLIC TRANSPORTATION
Transport for London
Tel.: +44 (0)20 72 22 12 34
(24 hour service)
www.tfl.gov.uk

Travel Card
Travel Cards are valid for travel on all public transportation. They are available for one, three or seven days. Peak fares are valid all day, Off Peak fares Mon–Fri from 9.30 am and all day on Sat/Sun and legal holidays. The Visitor Travel Card is valid for zones 1+2 in

which most sights are located. The card can be purchased in advance at a travel agency or online at Visit Britain, www.visitbritain.com, basic price £ 8.

Oyster Card
The Oyster Card comes with a rechargeable chip. The fare for trains and buses is paid electronically. Available at every tube and train station.

The tube network is complemented by a dense bus network. Night buses are marked with a blue "N" in front of the line number. There are two different bus stops: one is a white sign on a red circle where buses always stop and the other is a Request bus stop with a red sign on a white circle where buses only stop on request by hand signal. Tickets are available from ticket machines at the bus stops. Single fare £ 2.20. Cheaper are Travel Cards or Oyster Cards (see above) that are valid for one day and more.

Taxis
Tel.: +44 (0)871 871 8710,
Tel.: +44 (0)20 7272 0272,
Tel.: +44 (0)870 070 0700 (only available when calling from a mobile phone)

Bicycle Rentals
Take a cycle, ride it where you like, then return it, ready for the next person. Available 24 hours a day, all year round. It's self-service and there's no booking. Just turn up and go. Best for short journeys. Journey under 30 minutes are free.
www.tfl.gov.uk

Boats
London River Services operates a mixture of tourist and commuter boat services along the River Thames. For full details of all the services available on the River Thames check www.tfl.gov.uk/tickets/14413.aspx

CITY TOURS

SIGHTSEEING TOURS

By Bus and Tube
Inner London and a several area in London can be visited to a modest price with public transportation, e.g. with bus line Riverside 1, on the south side of the Thames departing from Catherine Street/Aldwych via County Hall and Tate Modern towards Tower Bridge and Tower Hill. Architecture and design fans can head for the tube stations designed by top-architects with the Jubilee Line.

Sightseeing Double-Decker Bus

Double-decker buses with an open-air roof circulate every 10 to 30 mins through Inner London, hop on/off is possible at every stop. Daily 8.30 am to 6 pm, 24-hour ticket approx. £18.

Big Bus Company
Tel.: +44 (0)20 7233 9533
www.bigbus.co.uk

Original London Sightseeing Tour
Tel.: +44 (0)20 8877 1722
www.theoriginaltour.com

Black Taxi Tours
Tel.: +44 (0)20 7935 9363
www.blacktaxitours.co.uk
Black taxi tours consider individual desires. Max. 5 pers., 2 hours £ 100

Peditaxis
www.londonpedicabs.com
Bicycle taxis seating from 2–3 pers. wait at several sights for customers to give them a ride through the city.

BOAT TOURS

Sightseeing

From the Thames you get a remarkable view on the city. The cruises depart all year round from Westminster Pier downstream towards Greenwich and the Thames Flood Barrier, during the season upstream via Kew and Richmond towards Hampton Court. Additional special cruises. Tickets from approx. £10, discount with a valid Travel Card.

Bateaux London, Tel.: +44 (0)20 7987 1185, www.catamarancruisers.co.uk

City Cruises, Tel.: +44 (0)20 7740 0400, www.citycruises.com

Thames River Boats, Tel.: +44 (0)20 7930 2062, www.wpsa.co.uk

London Duck Tours
Yellow amphibious vehicles allow combined sightseeing, both by road and on the Thames, daily departure at the London Eye, duration approx. 75 mins, Tel.: +44 (0)20 7928 3142, www.londonducktours.co.uk

Canal tours

Boat trip along the Regent's Canal from Little Venice, London Zoo and Camden Lock.

London Waterbus Company
Tel.: +44 (0)20 7482 2660
www.londonwaterbus.com

Jason's Trip, Tel.: +44 (0)20 7286 3428, www.jasons.co.uk

GUIDED TOURS

Blue Badge Guides
Tel.: +44 (0)20 7495 5504
www.tourguides.co.uk
Tailor-made tours and visits.

Theme tours

The 2-hour walks bring you e.g. to the Roman history of the city, through Shakespeare's, Sherlock Holmes's or Jack the Ripper's London, in different parts of the city or in the evening pubs crawls.

Original London Walks, Tel.: +44 (0)20 7624 3978, www.walks.com

Architectural Dialogue
Tel.: +44 (0)20 7380 0412
www.architecturaldialogue.co.uk
Every Sat 10 am approx. 3-hour tour.

Silver Jubilee Walkway
www.jubileewalkway.com
A 23 km / 14 miles long walkway on both sides of the Thames between Tower Bridge and Lambeth Bridge. From the starting point at Leicester Square just follow the crown pointing in the direction of travel. A map is available at museums and tourist information centres.

ART & CULTURE

www.firstthursdays.co.uk
Information on galleries that open late every first Thu of the month
www.officiallondontheatre.co.uk
Events calendar, theatre plays, tickets

www.royal.gov.uk
Official website of the British Monarchy providing information on Royal residences and art collections
www.timeout.com/london/art
Information on current exhibitions in galleries and museums
www.tate.org.uk/britain/eventseducation/lateattatebritain/
Exploring art after hours

GOING OUT

www.hardens.co.uk – Renowned restaurant guide for London and the UK
www.latenightlondon.co.uk
Information on clubs and bars with links
www.squaremeal.co.uk – Restaurant guide
www.thisislondon.co.uk
Leisure guide of the Evening Standard with a great events calendar
www.timeout.com/london
Restaurants, bars and a lot more as well as an extensive culture program
www.toptable.co.uk – Restaurant guide

COOL
CITY INFO

EVENTS

FASHION

www.londonfashionweek.co.uk
London Fashion Week showcases the latest trends in fashion design

ART & DESIGN

www.friezeartfair.com
Frieze Art Fair showcases new and established artists

www.londonartfair.co.uk
London Art Fair presents over 100 galleries featuring the great names of 20th century British art and exceptional contemporary work from leading figures and emerging talent

www.londonartsfestival.org – The London Arts Festival is one of the world's largest international festivals of the arts

www.tentlondon.co.uk
Tent London, a ground-breaking show at the Old Truman Brewery for forward-thinking design across all disciplines, delivering the very best contemporary and vintage design, architecture and interiors and the world of digital

www.londondesignfestival.com
Design Festival, celebrating the best international design

www.eastlondondesignshow.co.uk
East London Design Show, UK's independent product, interior and jewellery designers

MUSIC

www.brits.co.uk – Brit Awards

www.colf.org
City of London Festival, city festival with music, dance and theatre performances

www.thenottinghillcarnival.com
Notting Hill Carnival is the largest festival celebration of its kind in Europe

FILM

www.bfi.org.uk/lff
BFI London Film Festival bringing the world's best new films to London

COOL
CREDITS

COVER by Sylvain Grandadam/Hoa-Qui/Laif
Illustrations by Christin Steirat

p 2–3 (Samuel Beckett Mural, artwork by Alex Martinez, 2006) photo by Susanne Olbrich
p 6–7 (Red bus) by Peter Clayman (further credited as pecl)
p 8–9 (St Christopher's Place) by pecl
p 190 (South Bank) by pecl

HOTELS

p 12 (B+B Belgravia and The Studios@82) all photos by Anne Collard Photography; p 14 (Church Street Hotel) all photos by Britta Jaschinski; p 16 (High Road House) top left courtesy of Soho House, other by Simone Kaempfer; p 18 (The Savoy) all photos courtesy of The Savoy; p 20–22 (Rough Luxe Hotel) all photos by Marcus Peel, © Rabih Hage; p 24–26 (The Berkeley) all photos courtesy of The Berkeley; p 28–30 (Boundary) all photos by Paul Raeside; p 32–34 (Shoreditch Rooms) p 32–33 all photos courtesy of Soho House, p 34 top left and bottom all photos courtesy of Soho House, top right photo by Chris Tubbs; p 36 (Dean Street Townhouse) all photos courtesy of Dean Street Townhouse; p 38–40 (Sanctum Soho) all photos courtesy of Sanctum Soho Hotel; p 42 (The Soho Hotel) all photos courtesy of Firmdale Hotels; p 44–46 (40 Winks) all photos by Aliona Adrianova; p 48–50 (Haymarket Hotel) all photos courtesy of Firmdale Hotels

RESTAURANTS + CAFÉS

p 56–58 (Viajante) all photos by Ed Reeve; p 60–62 (Galvin La Chapelle) all photos by Jason Alden; p 64 (Lutyens) all photos by Paul Raeside; p 66–68 (Ottolenghi) all photos by pecl; p 70–72 (Zaika) all photos courtesy of Zaika; p 74–76 (Zuma) all photos by Martin Nicholas Kunz; p 78 (Goodman) all photos courtesy of Goodman Restaurants; p 80 (Hakkasan) all photos by Mark Whitfield; p 82 (E & O) all photos by Roland F. Bauer; p 84 (Albion) all photos by Paul Raeside; p 86–88 (aqua nueva) all photos courtesy of www.aqua-london.com

SHOPS

p 92 (Recipease) all photos by Matt Russell & David Loftus; p 94–96 (Holly&Lil Collar Couture) all photos by pecl; p 98 (The Chin Chin Laboratorists) all photos by Paul Denton; p 100 (Covent Garden) all photos by Susanne Olbrich; p 102 (Harrods) top photo courtesy of Harrods Ltd, bottom photo by Karsten Thormaehlen; p 104 (Daunt Books) all photos by pecl; p 106 (Portobello Market) all photos by Susanne Olbrich; p 108–110 (Borough Market) photos by pecl, p 110 top right by Heike Wild; p 112 (Paxton & Whitfield) all photos courtesy of Paxton & Whitfield; p 114 (Browns) all photos courtesy of Browns; p 116 (Liberty) all photos courtesy of Liberty; p 118 (St Christopher's Place) all photos by pecl

CLUBS, LOUNGES +BARS

p 122–124 (Circus) all photos by Mark Whitfield; p 126 (Artesian Bar) photo courtesy of Artesian Bar; p 128 (Mamounia Lounge) all photos courtesy of Web Design and development by InTouchCreative; p 130 (sketch) all photos courtesy of sketch; p 132 (supperclub) all photos by Geraldine Dorat; p 134–136 (Loungelover) all photos courtesy of Loungelover; p 138 (24 Club) left photo courtesy of 24 Club, right photo by Marcus Dawes; p 140 (aqua spirit) all photos courtesy of www.aqua-london.com

HIGHLIGHTS

p 146–148 (Canary Wharf) p 146, 147 photo by pecl and Vitek, p 148 all photos by pecl; p 150–152 (St Martin-in-the-Fields) p 150 by Phil Ashley, other by pecl; p 154–156 (BAPS Shri Swaminarayan Mandir) all photos courtesy by BAPS Pictures; p 158 (Primrose Hill) all photos by pecl; p 160–162 (Royal Botanic Gardens) all photos courtesy of RGB Kew; p 164 (BFI IMAX) all photos courtesy of BFI; p 166–168 (London Eye) all photos by pecl; p 170 (Shakespeare's Globe Theatre) all photos by Karsten Thormaehlen; p 172 (Lord's) top right by David Hare/MMC, other by Clare Skinner

COOL
CITIES

Pocket-size Book,
App for iPhone/iPad/iPod Touch
www.cool-cities.com

A NEW GENERATION

of multimedia lifestyle travel guides
featuring the hippest most fashionable
hotels, shops, and dining spots for
cosmopolitan travelers.

VISUAL

Discover the city with tons
of brilliant photos and videos.

APP FEATURES

Search by categories, districts, or geo locator;
get directions or create your own tour.

COOL
BERLIN

With special tips
from Tita von Hardenberg

A new visual guide to the coolest hotels, restaurants,
cafés, clubs, bars, lounges, shops, highlights and more

teNeues

ISBN 978-3-8327-9486-6

BRUSSELS
VENICE
BANGKOK
MALLORCA+IBIZA
NEW YORK
AMSTERDAM
MIAMI
MEXICO CITY
HAMBURG
LONDON
ROME
MILAN
BERLIN
FRANKFURT
STOCKHOLM
BARCELONA
COPENHAGEN
LOS ANGELES
SHANGHAI
TOKYO
SINGAPORE
VIENNA
BEJING
COLOGNE
PARIS
HONG KONG
MUNICH

ART
ARCHITECTURE
DESIGN

**Pocket-size Book,
App for iPhone/iPad/iPod Touch**
www.aadguide.com

A NEW GENERATION

of multimedia travel guides featuring
the ultimate selection of architectural
icons, galleries, museums, stylish
hotels, and shops for cultural and
art conscious travelers.

VISUAL

Immerse yourself into inspiring
locations with photos and videos.

APP FEATURES

Search by categories, districts, or
geo locator, get directions or create
your own tour.

ISBN 978-3-8327-9435-4

COPENHAGEN
BARCELONA
SHANGHAI
TOKYO
SINGAPORE
BEIJING
VIENNA
PARIS
SYDNEY
HONG KONG
MUNICH
ZURICH
NEW YORK
SAO PAULO
AMSTERDAM
MIAMI
MEXICO CITY
HAMBURG
LONDON
ROME
EMIRATES
CHICAGO
MILAN
BERLIN

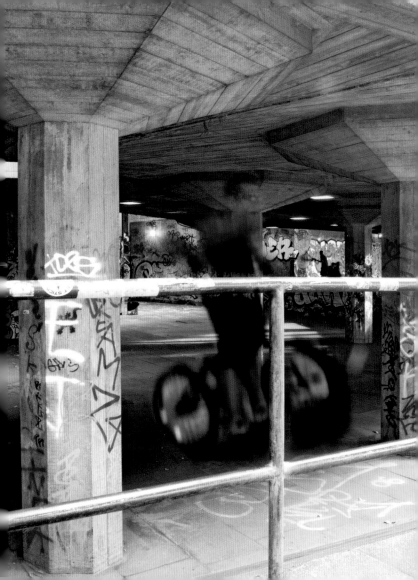

© 2011 Idea & concept by Martin Nicholas Kunz, Lizzy Courage Berlin
Selected, edited and produced by Susanne Olbrich, Christine Takengny
Introduction, backcover and location texts by Clare Rigden; city info by Susanne Olbrich,
Christine Takengny; area texts by Christine Takengny
Executive Photo Editor: David Burghardt
Editorial coordination: Susanne Olbrich, Christine Takengny, Jana Härter
Copy Editor: Dr. Simone Bischoff
Art direction: Peter Clayman, Susanne Olbrich, Lizzy Courage Berlin, Design Assistant: Sonja Oehmke
Imaging and pre-press production: mace.Stuttgart, David Burghardt
Translations: Übersetzungsbüro RR Communications Romina Russo,
Bianca Dett, Romina Russo (German), Pierre Fuentes, Romina Russo (French),
Pablo Álvarez, Romina Russo (Spanish)

© 2011 teNeues Verlag GmbH + Co. KG, Kempen

teNeues Verlag GmbH + Co. KG
Am Selder 37, 47906 Kempen // Germany
Phone: +49 (0)2152 916-0, Fax: +49 (0)2152 916-111
e-mail: books@teneues.de

Press department: Andrea Rehn
Phone: +49 (0)2152 916-202 // e-mail: arehn@teneues.de

teNeues Digital Media GmbH
Kohlfurter Straße 41–43, 10999 Berlin // Germany
Phone: +49 (0)30 700 77 65-0

teNeues Publishing Company
7 West 18th Street, New York, NY 10011 // USA
Phone: +1 212 627 9090, Fax: +1 212 627 9511

teNeues Publishing UK Ltd.
21 Marlowe Court, Lymer Avenue, London SE19 1LP // UK
Phone: +44 (0)20 8670 7522, Fax: +44 (0)20 8670 7523

teNeues France S.A.R.L.
39, rue des Billets, 18250 Henrichemont // France
Phone: +33 (0)2 4826 9348, Fax: +33 (0)1 7072 3482

www.teneues.com

Bibliographic information published by the Deutsche Nationalbibliothek.
The Deutsche Nationalbibliothek lists this publication in the
Deutsche Nationalbibliografie; detailed bibliographic data are
available in the Internet at http://dnb.d-nb.de.

Printed in the Czech Republic
ISBN: 978-3-8327-9488-0